Vieira da Silva

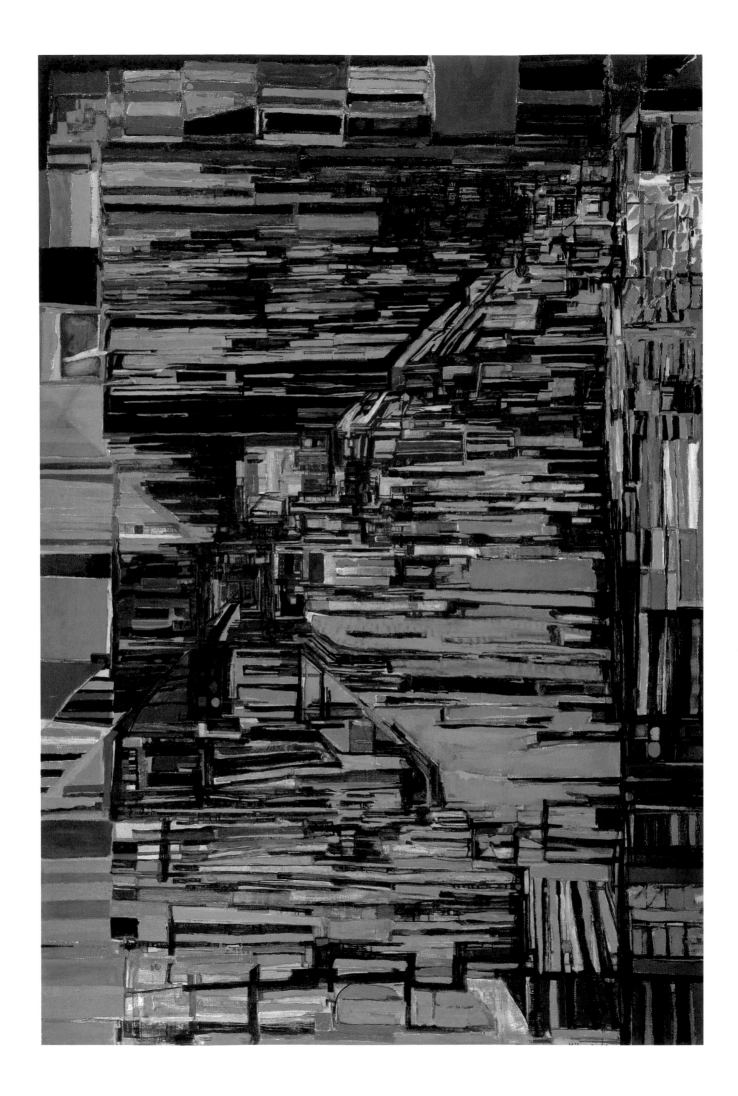

Gisela Rosenthal

VIEIRA DA SILVA

1908–1992

The Quest for Unknown Space

TASCHEN

KÖLN LISBOA LONDON NEW YORK PARIS TOKYO

COVER:
Ariadne, 1988
Ariane
Oil on canvas, 130 x 97 cm
Paris, Gallery Jeanne-Bucher Collection

BACK COVER:
The artist's hand

PAGE 1:
Sirens and Self-Portrait, 1939
Sirène et autoportrait
Plume and coloured pencil on paper, mounted on cardboard, 26 x 13.5 cm
Lisbon, Fundação Arpad Szenes – Vieira da Silva

PAGE 2:
The Steps, 1964
Les degrés
Oil on canvas, 195 x 130 cm
Lisbon, Centro de Arte Moderna, Calouste Gulbenkian Collection

© 1998 Benedikt Taschen Verlag GmbH
Hohenzollernring 53, D–50672 Köln
© for the illustrations Vieira da Silva: 1998 Gallery Jeanne-Bucher, Paris
© for the illustrations by Alberto Giacometti and Henri Matisse:
1998 VG Bild-Kunst, Bonn

Edited by Yvonne Havertz and Michael Konze, Cologne
English translation by Michael Hulse, Cologne

Printed in Germany
ISBN 3-8228-8269-0
GB

Contents

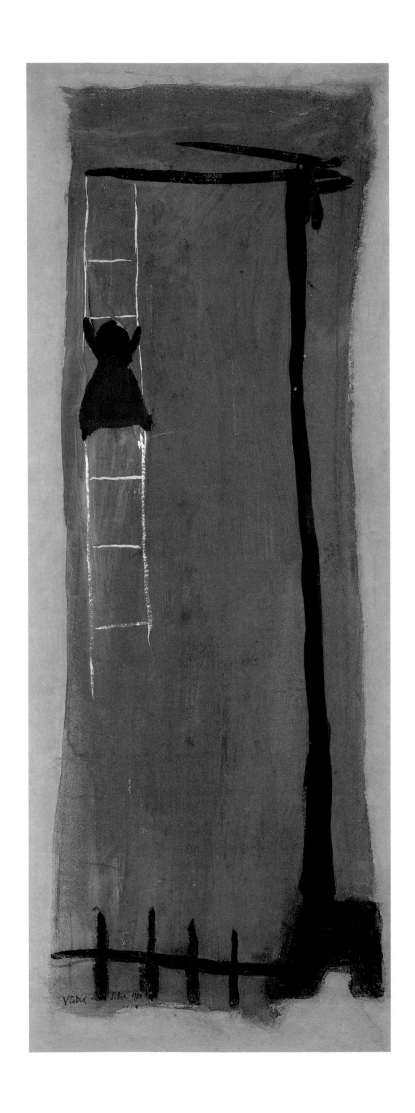

The Irreplaceable Loss
Lisbon 1908–1927

"Homo pictor does not merely produce cave paintings for magical
hunting practices, but is also the being who covers up the lack
of security in his world by projecting images on it."

H. BLUMENBERG

On an unevenly shaped green surface, white brush strokes delineate a ladder
hung in the air from tall scaffolding. We see a little girl from behind, standing
on one of the rungs. Her head is upturned as she assesses the climb ahead of
her. The choice of title for this painting, *Self-Portrait* (1932, p. 6), comes as
a surprise to the viewer. Maria Helena Vieira da Silva was twenty-four years
old and had already painted herself as a young woman several times when
she produced this portrayal of herself as a child between heaven and earth.
Conversations and interviews with da Silva confirm just how important the
first years of her life were to her painting. When she talked about that period,
she did so hesitantly, in words that left things unsaid, indeed unutterable. Her
discourse about her life and work as a whole was marked by the meticulous
care with which she used language. This wavering between the urge to reveal
herself and the fear of touching on painful matters was also reflected in the
life-long refinement of her unmistakable pictorial idiom.

My memories go back to a very early age. I started to live when I was two
years old, really to live and think, and that life became a complete world. The
first impressions I recall are of Christmas in Switzerland. I can still see the
snow, the mountains, the skiers, the sledges…"[1] Vieira recalled the corridors
of the sanatorium and the room which her parents lived in; she herself shared
another with her Portuguese governess. She did not touch on the experience
that triggered these memories, but it made an indelible impression, for her sick
father, an embassy attaché and son of a diplomat, had gone to Leysin with his
family in the winter of 1910 in order to heal his tuberculosis. He died in the
sanatorium in February 1911.

Everything suddenly changed for the child. "I discovered at a very early age
the transitoriness of life," she was later to recall; "I realised that all things pass
very quickly." And she added an impersonal explanation that deflected scrutiny
from herself: "You also learn that when you live in a town situated practically
on top of a volcano and right by the ocean." The death of her father had torn
the veil of forgetfulness that normally protects us from our earliest childhood
experiences. It produced a storm of doubts and anxieties which continued to
plague her throughout life. It was a traumatic experience that robbed her of the
feelings of security and continuity that can only develop in the safety of one's
first years of life. This confrontation with human mortality was the experiential
backdrop against which she grew up and her work matured.

Da Silva vividly described the atmosphere in her grandparents' house in
Lisbon, which she lived in from 1911 to 1926 with her silent, dreamy mother:

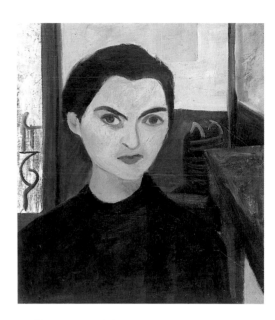

Self-Portrait, 1930
Autoportrait
Oil on canvas, 54 x 46 cm
France, private collection

PAGE 6:
Self-Portrait, 1932
Autoportrait
Gouache on paper, 67 x 26 cm
Lisbon, Maria Nobre Franco Collection

Self-Portrait, 1931
Autoportrait
Gouache on paper mounted on cardboard,
50 x 33 cm
Lisbon, Fundação Arpad Szenes –
Vieira da Silva

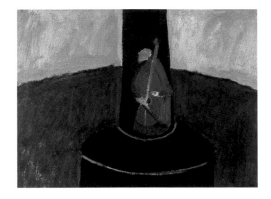

The Cellist III, 1930
Le violoncelliste III
Gouache on paper mounted on cardboard,
29.5 x 40 cm
Portugal, private collection

To Explain Sintra to Arpad, 1932
Pour expliquer Sintra à Arpad
Oil on paper mounted on cardboard,
30 x 40 cm
Lisbon, Fundação Arpad Szenes –
Vieira da Silva

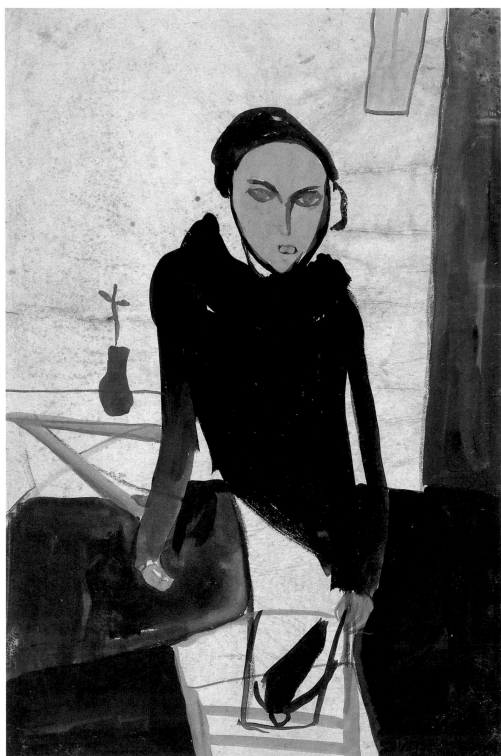

"I think I just took to painting as a child. I was the only child in an enormous house big enough to get lost in. There were lots of things there, lots of books, maps and pianos. I had no friends in that house, with my mother who had been widowed at an early age, and I did not go to school either. Frequently no one was at home at all. I was taught to read when I was still very young, Portuguese, French and English all at the same time, more or less, and I learnt to play the piano; I was allowed to touch anything. That is how I lived, completely isolated in a world of grown-ups whose conversations I would listen to. At times I was completely alone and often very sad, profoundly sad. At such times I would escape into the world of colours and the world of sounds. I think it all merged together into a whole." In order to escape her

boredom and loneliness, she followed the advice of the adults: "Look, look, look at that tree, look at that bird … listen to music, listen to the sounds, the rain, listen to it, it's all so lovely … and they also said to me: look at the sky, the stars. And the little bored girl began to look and listen.

Vieira spent hours engrossed in her doodled drawings, filling exercise books with her own picture stories. She played the piano, read and listened to music. At the age of five she already knew she wanted to become a painter, even though she did not consider herself talented: "But I was thick-headed, I concentrated and I was conscientious. I believe I have a sort of plastic intelligence which is perhaps more pronounced than any other aspect of my personality. Even as a child I was already searching in a particular direction."

Vieira was a child with an insatiable thirst for knowledge and an exceptional memory on which everything made an impression, in particular anything to do with death. The abiding image that remained in her mind from a trip to London was that of an Egyptian mummy. At the start of the First World War, she was haunted by the Apocalypse; her mother and aunt read a few verses out of it every evening as a metaphor for the horrors of war: "The atmosphere of those readings, heard by candlelight in a damp country house, the angels' trumpets and the horses haunted the child from then on," she wrote in a short autobiographical memoir. Soon afterwards she found a Portuguese magazine amongst her grandfather's books, in which Dürer's engravings of the *Four Horsemen of the Apocalypse*, *Melancholia* and *St. Stephen* were reproduced. The girl wanted to have them before her eyes continuously, so she cut the prints out,

Portrait of Arpad, 1931
Portrait d'Arpad
Pastel on paper, 46 x 65 cm
Portugal, private collection

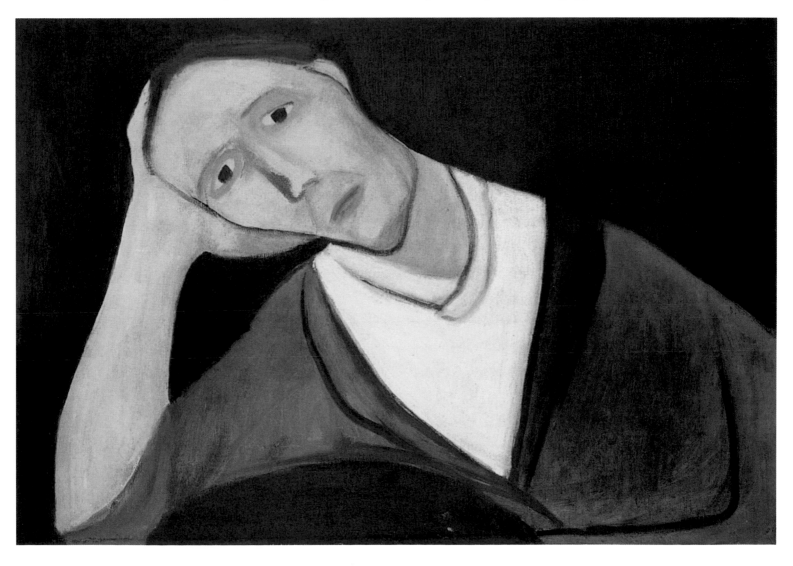

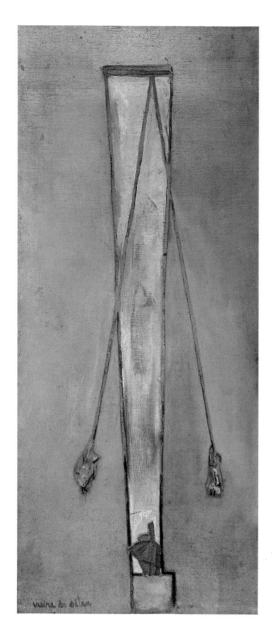

The Swings, 1931
Les balançoires
Oil on canvas mounted on canvas,
130.5 x 54 cm
Lisbon, Fundação Arpad Szenes –
Vieira da Silva

had them framed and hung them on the wall. Raphael's *The Virgin and the Skeleton* also made a lasting impression on her. At her grandmother's graveside she reflected "that she was really lying there, because she had always stated that she did not believe in a life after death." Her grandmother had always been a good listener to her questions about death, and willing to respond, for which she was grateful to her for the rest of her life: "she helped me greatly, she was marvellous to me."

Vieira hoarded disconnected fragments of knowledge as if they were valuable finds, and wove them into a personal puzzle. In this way she continued to gather her insights, even as an adult: "I acquire my learning, my knowledge, by tying threads together piece by piece, constantly adding more, until there is a knot inside me." As a result of her painful experience of transitoriness and insecurity, she invented a world of her own. It protected

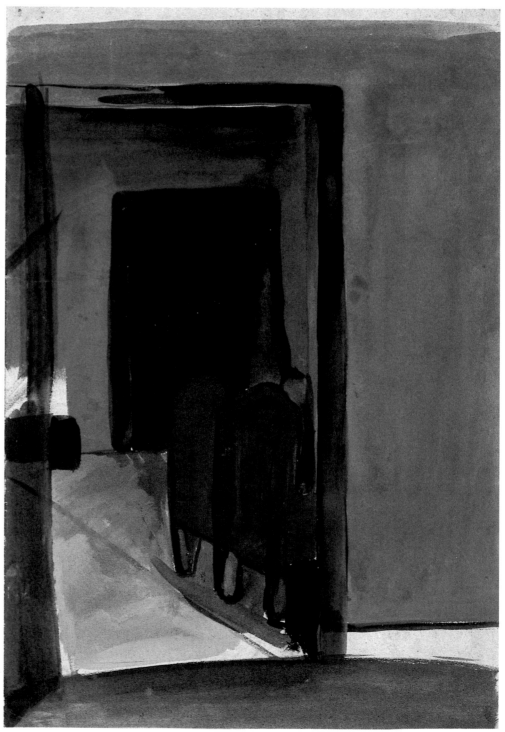

The Two Doors, 1930
Les deux portes
Gouache on paper mounted on cardboard,
41 x 29 cm
Lisbon, Maria Nobre Franco Collection

The Tree in the Prison, 1932
L'arbre en prison
Ripolin on canvas, 40.5 x 33 cm
Lisbon, Fundação Arpad Szenes –
Vieira da Silva

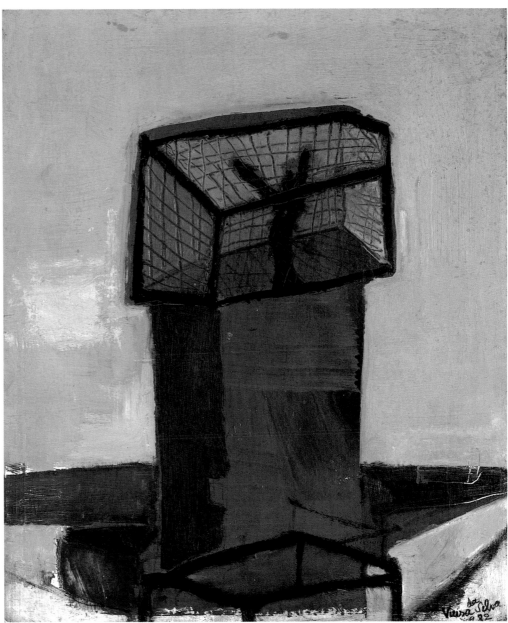

Freedom Lies with Us III, 1934
A nous la liberté III
Gouache on paper, 67 x 26 cm
Lisbon, private collection

her from the fear and anxiety that she felt as constantly "as our heartbeat and breathing: 'I was forever struggling to escape that fear. When I was young, it was already there, inside me." The self-portrait as a little girl echoed one of her first childhood pictures in which she attempted to come to terms with the loss of her father and her early sense of a rift between the self and the world.

Young Vieira never went to school, but was taught by a succession of home tutors. In 1919 three new subjects were added to her usual studies – music, drawing and painting. Initially, music held an irresistible attraction for her. She even wrote some compositions of her own. "But I fortunately gave it up again – I did not have the necessary talent to make good music. Something did, however, take shape in me at that time. While I remained faithful to painting, by nature I have a greater love for music. It gives me greater pleasure. But painting was the only area where I could overcome my lack of talent." This preference was to remain with her throughout her life. A harmonium or piano was part of the furnishings in every studio and flat she lived and worked in. While she was still living in her grandparents' house she discovered the composers Ravel and Debussy, and they gave her access to contemporary music.

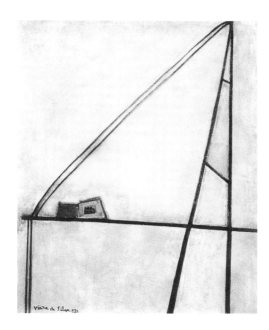

The Swing Bridge in Marseilles, 1931
Le pont transbordeur de Marseille
Oil on canvas, 100 x 81 cm, (lost)

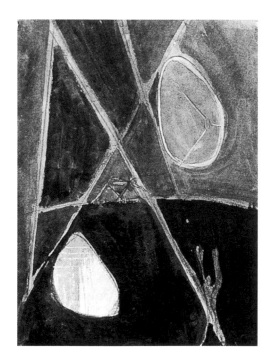

Work, 1933
Le travail
Oil on paper mounted on cardboard,
40.4 x 30 cm
France, private collection

The Quay at Marseilles, 1931
Le quai de Marseille
Pastel on paper, 40 x 29 cm
France, private collection

But her decision in favour of painting had finally been made. As a ten-year-old, she destroyed all the drawings and sketches which she had produced so far, because she was ashamed of their childishness. In all awareness of what she was doing, she meant to start again from scratch. Presently, art classes at the College of Fine Arts in Lisbon were added to her drawing lessons; and in 1924 she decided to study modelling. She was concerned from the start to avoid copying the work and styles of other painters, and took her subjects from the real world around her. From 1926 onwards she applied herself to anatomical drawing, in the hope that this would bring her even closer to her subjects.

Since 1915, Vieira had been spending her summers in Sintra, in a house that her mother had bought there. She never tired of the view across the valley, where she made her first studies of nature. She recalled one summer afternoon particularly clearly: "I was 15 years old … I was looking out over a wonderful, wide landscape. I projected things I had read, musical memories, and images onto the things I saw; it all conjoined with the trees, the sky.

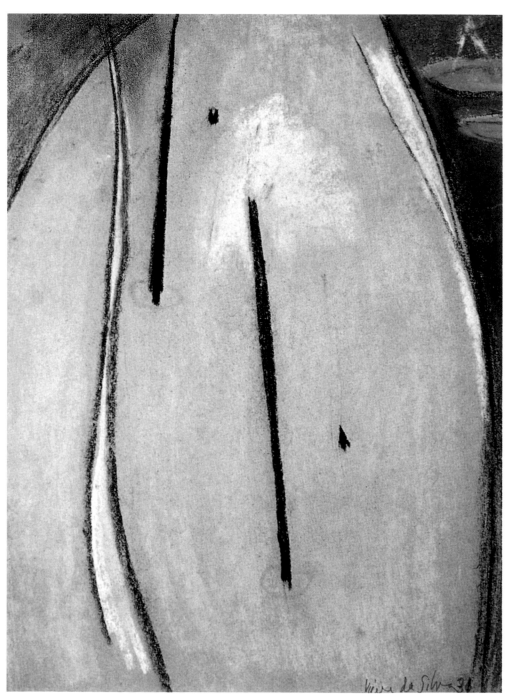

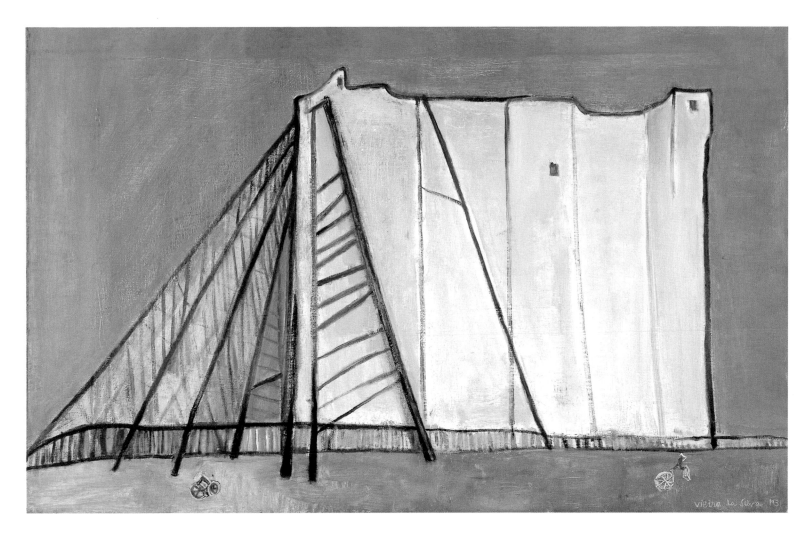

I felt that a picture should be an amalgamation like that. I myself was adding something to it that only existed in me, an enchantment, an endless amazement. That was what I wanted to paint." For da Silva, the view from Sintra, with the almost symmetrical hills on the horizon at the end of the little valley, retained something of the character of a vision which her later pictures had to measure up to. She attempted to realise her memory of it in two small paintings produced in Paris in the early Thirties (cf. *To Explain Sintra to Arpad*, 1932; p. 8) in order to convey her experience to the artist Arpad Szenes. In Sintra, hidden up a tree in the garden of the house at the age of seventeen, she read Aeschylus' *Prometheus Bound* in a single sitting. It became her master metaphor of the world: "All the suffering of humankind was already present in him. It was a great discovery for me, and I was deeply moved by it. It has such beauty to it, such greatness!"

When she was eighteen, she started asking herself with some concern how it was possible to paint all of these things and still be of her own times. "I comforted myself with the assurance that I would find a way in Paris." In early 1928 she moved to the French capital with her mother. "I had reached a stage in my work when I needed to go to Paris. I could not continue to develop in Lisbon. The pictures I was painting there no longer satisfied me. I had no idea either what to do or how to do it. I had taken up sculpture and that was very useful as it kept me in touch with reality."

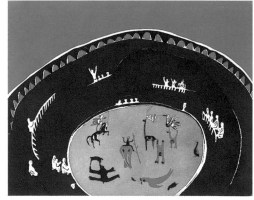

The Circus (Kô and Kô, panel XI), 1933
Le cirque (Kô et Kô, planche XI)
Gouache on paper, 24.5 x 32 cm

White Marseilles, 1931
Marseille blanc
Oil on canvas, 54 x 81 cm
France, private collection

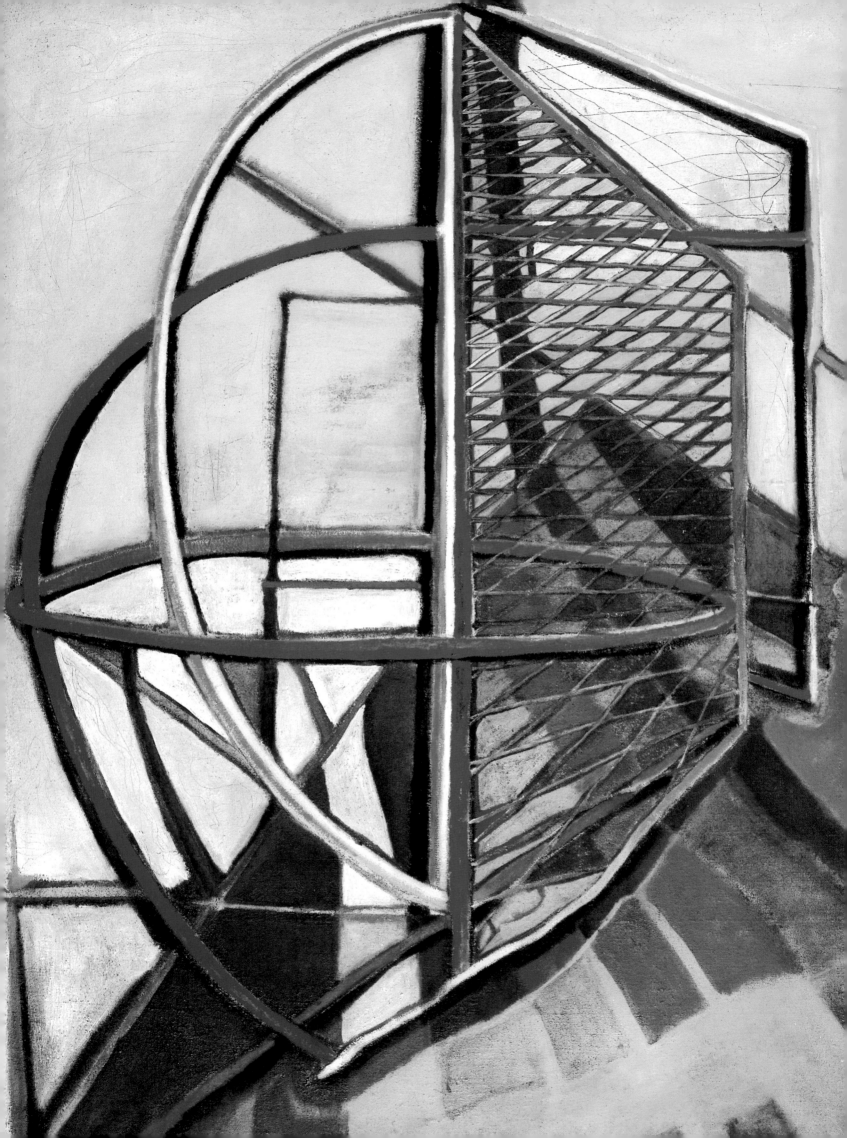

The Theatre of the World
Paris 1928–1939

"Feelings are the substance of my business. I believe
myself to be impervious."

PAUL CÉZANNE

"I needed the tool with which one can press on ahead into
unknown space, and the only place I could find it was Paris."

VIEIRA DA SILVA

Da Silva was nineteen when she and her mother settled in the Medical Hôtel in the Rue Faubourg St. Jacques. She went on long walks through the city, discovering old and contemporary works of art in galleries, museums and exhibitions. When she first went into the Louvre, she felt "lost, had great difficulties comprehending the *depth* of the old works ... did not succeed in covering the *distance* between us and them ... and, due to this *distance*, I had scruples about copying them" (my italics). In contrast, she felt a spontaneous closeness to the Impressionists. By dissolving the surface of the picture into countless dots of colour, they had abandoned the traditional means of depicting space, recording merely the impressions of light and colour reflections perceived by the eye. The works of van Gogh dissolved the imitation of spatial reality into a whirlwind of brush strokes, and Gauguin's figures and landscapes transformed it into linear, outlined coloured surfaces. It was Cézanne who attracted the young artist most strongly. In his paintings, he had attempted to make the structures underlying the visible reality, and had found new ways of representing space.

Her contemporaries, the second generation of modern artists, took up the lessons of these masters who flourished around the turn of the century. The First World War, which lay less than a decade in the past, had also shaken the Paris art scene. The old order of the western world had been irrevocably destroyed; the old certainties, laws and convictions had lost their validity; the rift between man and the world had become insuperable. The age when there was a comprehensive philosophy of life, and the conviction that it could be translated into art, was over. The mirror held up to nature was broken, and artists now chose between the shards, of the confusingly diverse styles, as they attempted to develop the forms of expression which they believed would best enable them to present the matters they were concerned with. Da Silva encountered these new artistic currents, which at the time made Paris the centre of western art, in the works of Braque and Picasso, Duchamp, Dufy, Utrillo, Mondrian, Modigliani, Matisse and the Surrealists. "The first shock, immediately after I arrived in Paris, was seeing a portrait painted by Picasso. This portrait gave me a more humane, immediate sense of painting. At the time, painting had become dynamic once again. I looked, drew lessons from everything but always remained on the sidelines. Impressionism, Cubism and abstract art all enriched me, but I never wanted to belong to a particular sect." She was not able to identify

Torres García
**Symmetrical Universal Composition in
White and Black**, 1931
Oil on canvas, 175.3 x 89.5 cm
USA, private collection

PAGE 14
Composition, 1936
Composition
Oil on canvas, 146 x 106 cm
Lisbon, Fundação Arpad Szenes –
Vieira da Silva

Ambrógio Lorenzetti
Life in the Country
From: *The Effects of Good Government*
(detail), c. 1337–1340
Fresco, 296 x 1398 cm (total)
Siena, Palazzo Pubblico

Studio, Lisbon, 1934–35
Atelier, Lisbonne
Oil on canvas, 114 x 146 cm
Lisbon, Fundação Arpad Szenes –
Vieira da Silva

spontaneously with any one of the modern trends. Her starting point was always tradition. She saw herself as an outsider and aimed to discover her own specific means of expression along untrodden paths. And despite the lively scrutiny of the premises of art that was being pursued during her lifetime, she never lost sight of her goal.

Months later, as other visual experiences made their impact on her, the break which da Silva had felt there to be between the old masters and contemporary art became clear to her. During the course of a study trip to Milan, Verona, Padua, Venice, Bologna, Siena, Florence, Pisa and Genoa during the summer of 1928, she was filled with enthusiasm mainly for the works of the Italian masters of the Trecento and Quattrocento. A new concept of pictorial space was revealed to her in the panel paintings and frescoes of the late Middle Ages and early Renaissance. Giotto, Simone Martini, Pietro and Ambrógio Lorenzetti, Masaccio and Uccello had used linear perspective to transform into a representation of space that could be assessed with the human eye that sacred, symbolic area of two-dimensional picture surfaces which had hitherto consisted of a golden ground behind the figures of saints and biblical scenes. Their work brought home to her that space was relative, intimately connected to the historical moment in

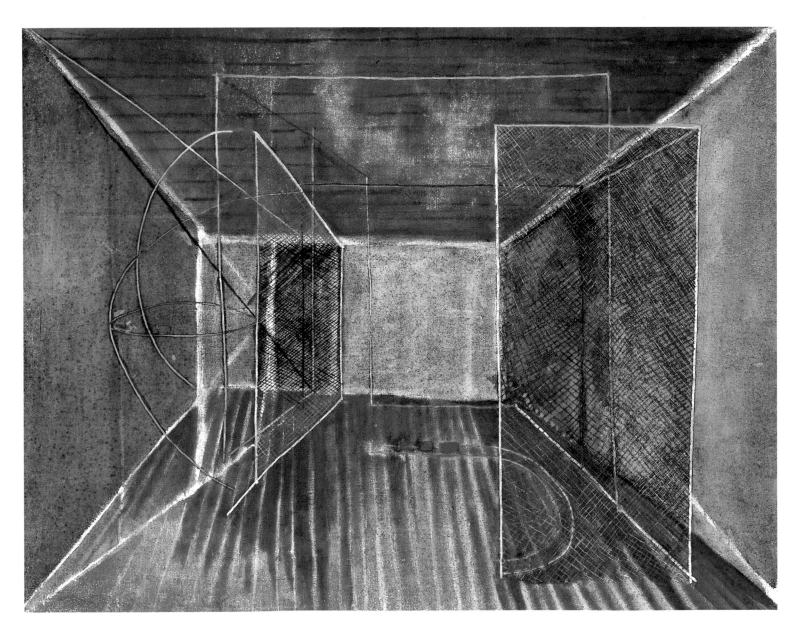

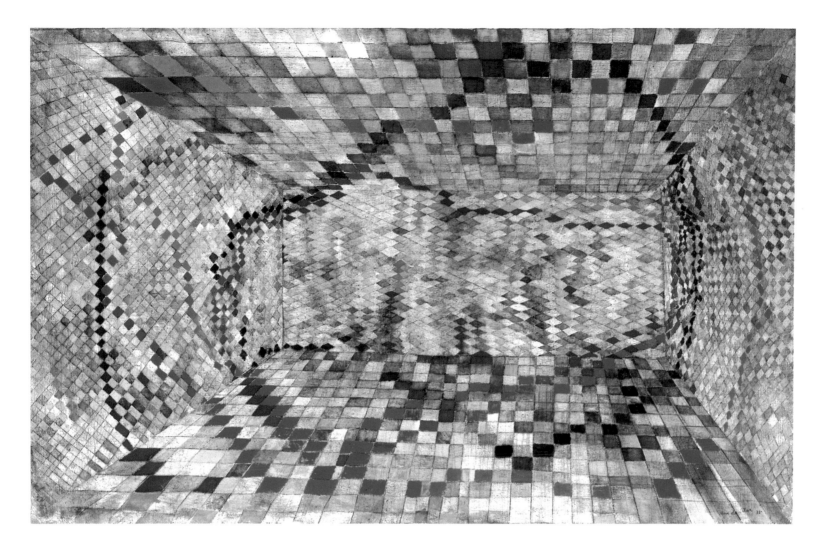

time, and dependent upon the prevailing philosophy of the age. This historical dimension made it clear to her that the *depth* and *distance* which had disturbed her in the old masters' paintings derived from their use of central linear perspective. Ever since the Renaissance, it had dominated western art. The difference of modern art could be explained as the consequence of an altered perception of space. Da Silva perceived that the relationship between space and figure, which had undergone continual reformulation over the centuries, was a common denominator in the varied forms and styles of western art.

Ambrógio Lorenzetti's fresco Storie del Buono e del Cattivo Governo (c. 1337–40) in the Palazzo Pubblico in Siena proved the most unforgettable experience of her journey, and one which also pointed the way she should take. She saw the broad panorama, which connected the city and its surrounding countryside to the representation of the most diverse human activities, as a comprehensive vision of the vastness of the world. The gigantic mural painting with its constructive treatment of space seemed like an echo from afar, responding to her ideas concerning the reproduction of the totality of things: "Everything must be vibrant and alive. They talk about reality. But everything astonishes me and I paint my astonishment, which is at once enchantment, horror and laughter too. I do not wish to exclude anything from this astonishment. I want to paint pictures that include a great many things, that are rife with contradictions, with the unexpected… I would like to become so skilful, so certain of my movement and voice, that nothing can escape me; whether the weightlessness

The Tiled Room, 1935
La chambre à carreaux
Oil on canvas, 60 x 92 cm
England, private collection

17

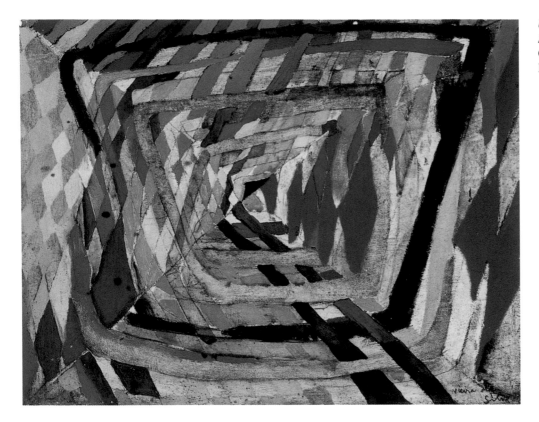

Untitled, 1935
Sans titre
Oil and pencil on panel, 22.8 x 28.9 cm
Portugal, private collection

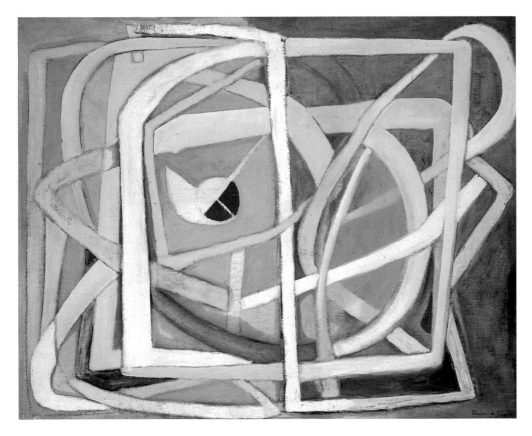

Composition, 1936
Composition
Oil on canvas, 81 x 100 cm
Lisbon, Centro de Arte Moderna,
Calouste Gulbenkian Collection

of birds, the weight of stones or the sheen of metals. I should like to direct my full attention to the strings that lead people and bind them fast. To do that, one would have to go everywhere, dancing, making music, singing, flying, right down to the depths of the oceans, watch lovers, visit factories and hospitals, learn poems, civil rights and the history of the nations by heart…"

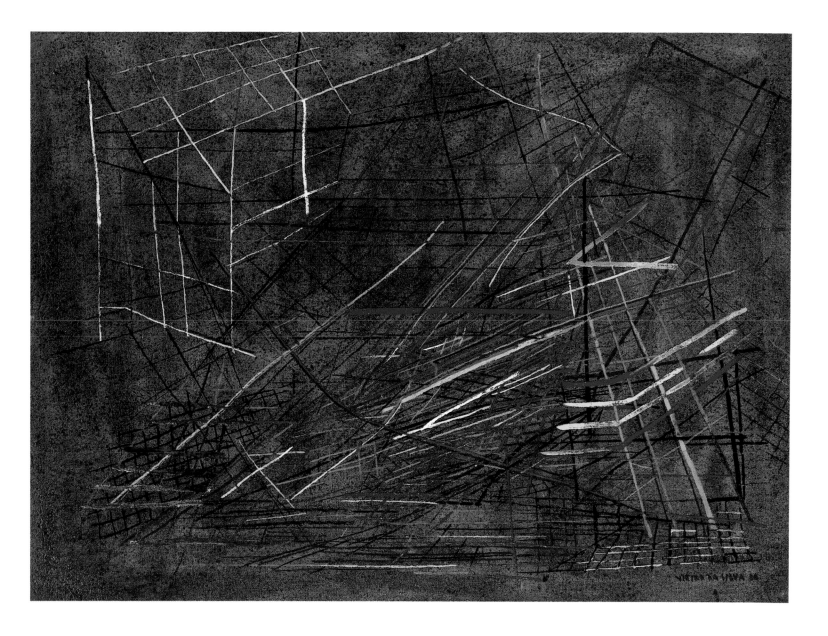

The Lines, 1936
Les lignes
Oil and ripolin on canvas, 70 x 92 cm
Paris, Musée national d'art moderne,
Centre Georges Pompidou

Back in Paris, da Silva patiently persevered with her studies: "Every-thing became easier now I had taken the first step. I no longer doubted that I would one day be able to paint my enchantment." Her search had found a direction, and she would henceforth evolve her own pictorial idiom in parallel with a new rendering of spatiality. She continued her study of drawing at the Académie de La Grande Chaumière and worked for a while in the studio of Bourdelle the sculptor. "At least, with sculp-ture, I knew how I could convert what I saw. I never contemplated becoming a sculptress; I created sculptures in order to remain more free in my painting." Very little trace remains in her works of the lessons taught her by the artists Dufresne, Waroquier, Friesz and lastly Bissière, whom she visited in succession until 1933. A short period in the studio of the painter Fernand Léger acquainted her with paintings displaying a fascination with the technical inventions of the age that she shared: "I understood how very much life had changed in this century, and how powerful its dynamism was." For the same reason, she was interested in the representation of speed and movement in the work of the Italian Futurist painters and sculptors. She did, however, successfully avoid any direct influence, and kept her art free of other people's experiences. She only integrated what appeared relevant to her own purposes.

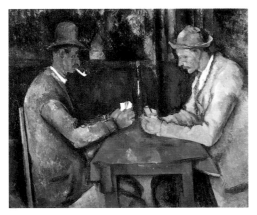

Paul Cézanne
The Card Players, 1893–96
Les joueurs de cartes
Oil on canvas, 46 x 56 cm
Paris, Musée d'Orsay

The Siren, 1936
La sirène
Oil on panel, 30 x 61 cm
Portugal, private collection

Da Silva had met the Hungarian painter Arpad Szenes at the art academy shortly after she first came to Paris. His critical comments on her drawing technique made a great impression on her. When Arpad returned a year later, after a period in his native city of Budapest, it was his turn to be amazed at her progress. A lifelong relationship started between them, its constant artistic dialogue being reflected in the work of both artists. Szenes, who was eleven years the elder, put his own work second to da Silva's artistic career, and contrived to shield her from everyday worries on matters such as money. But above all, he liberated her from the profound artistic doubts that she was periodically beset by. Talking to Anne Philipe, Arpad described Vieira in these terms: "She is vulnerable and melancholy, she needs a degree of moral support. She has never believed enough in her own talent, either in her vocation or in what she is capable of."[3]. Da Silva herself described the period in this way: "I was feeling my way forward. I knew that I wanted to take a certain route, but I did not know which precisely... Since my marriage, even before it, I chose a route that I wanted, but I often followed it hesitantly..."

A painting in the Louvre inspired her to produce one of her first series of pictures: "I remember ... I was wandering about the rooms searching for the key that would enable me to get clear of this art which confused and frightened me. And then I found it. At the top, right at the far end of the Louvre, there was a room of Impressionists. On the rear wall were three paintings by Cézanne: *Landscape*, the great *Still Life with Oranges* and between them *The Card Players*. These two men who never stopped shuffling and dealing the cards... That was the key for getting to the other side of the *wall* which on first sight had *no way through*" (my italics). The

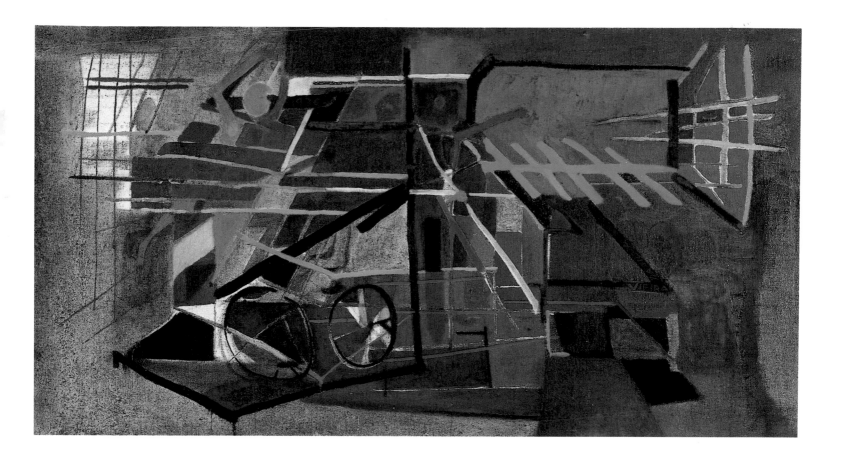

The Street, the Evening, 1936
La rue, le soir
Oil on canvas, 54 x 100 cm
Lisbon, Centro de Arte Moderna,
Calouste Gulbenkian Collection

spatial section in which the table and players are presented in Cézanne's painting is suggestive of a further space, shrouded in darkness, behind the men. Two shadowy figures facing each other appear to be as absorbed in what they are doing as the players in the foreground. In an age when the the problem of representing space by means of perspective was considered to have been overcome, the great master of modern art had become interested in ways of reproducing spatial continuity and discontinuity in painting. And to do this he had chosen a subject which he was not alone in taking to be a metaphor of life. This provided da Silva with a solution to her own attempts, which she had hitherto felt to be anachronistic, to present adjacent spatial zones in a painting. "Cézanne is a support… Cézanne is there to teach us the grammar and to be admired. But I have to develop as I am. Precisely that is what I am trying to do. And I take whatever I need wherever I find it."

The self-portraits showing da Silva in her own Paris studio flat, where she lived with Arpad from 1930 onwards, reflected the central concern in her pictorial quest. In a pastel dating from 1931, she placed a closed door next to the sketched outline of her head and shoulders. In the gouache *Self-portrait* (1930, p. 7) she presents herself defined against the opaque brightness of a window. In *Family Portrait* (1930, p. 39) of 1930 we see, beyond her own challenging, critical gaze and the silhouette of Arpad at the easel, a door which opens onto a further room where, in the darkness, a further person can be made out, probably her mother. Doors and openings are repeated in other drawings and gouaches of the period. Clearly differentiated spaces which border on or merge into each other represent her first attempt to get to grips with the "existential dimension of space"[4]. It is

21

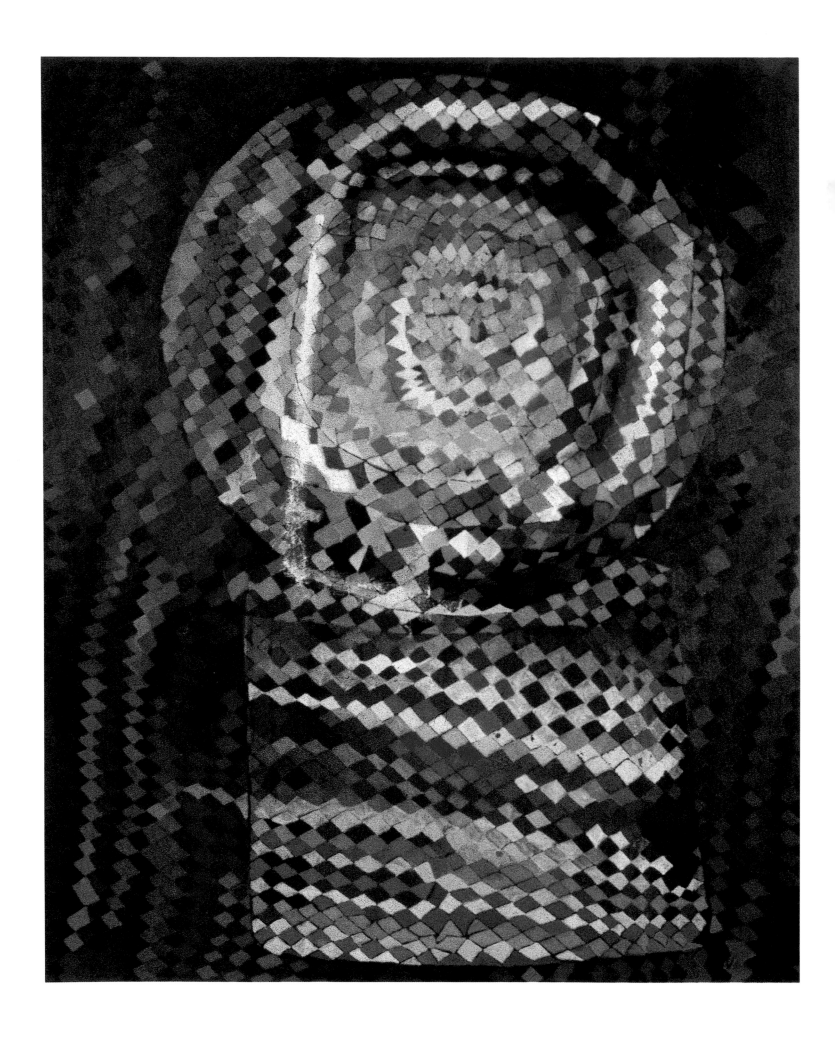

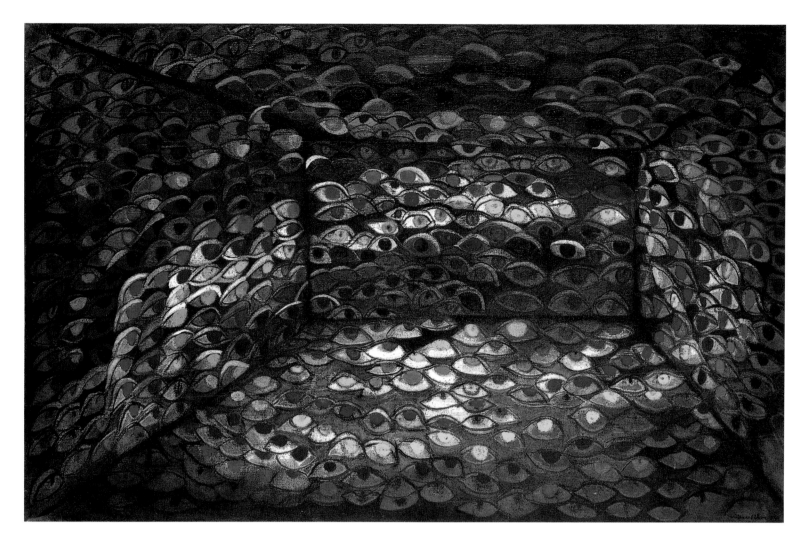

the place for the figurative representation, and at the same time it is a self-contained theme. "Doors are very important for me. For a long time now I have had the impression that I am standing before a locked door, and that important things that I cannot know or see are happening on the other side. Only death can open that door..."

The entry into a second room, one that cannot quite be made out with the eye, was also her theme in a number of sketches which she produced in 1930 on a visit to Arpad's native Hungary and to Transylvania. Back in her Paris studio, she took up two other themes from this journey for further work, which resulted in her first large-format painting. In a series of gouaches the figure of a cellist playing his instrument on a circular, open air platform was given various treatments. On this motif she superimposed that of a merry-go-round from a hasty pencil sketch. Finally, in *The Swings* (p. 10), the last, vertical-format version dating from 1931, we have a bird's eye view of the tiny musician at the bottom edge of the canvas. The high rear wall of the stage, with long ropes attached to it, extends right to the top edge of the picture. Two human figures are swinging on the ropes through the space either side of the platform, as if balanced on scales. Da Silva once made a cryptic but apt remark on this unusual angle of view, which she used here for the first time: "I paint locations as if they were seen from afar."

She returned to the subject between 1932 and 1934 in a series of smaller works. In *The Merry-go-round* it is not seats but men and women who are going around in circles attached by strings. In the next version, the conceit

"La Scala", or "The Eyes" 1937
«La Scala» ou «Les yeux»
Oil on canvas, 60 x 92 cm
Paris, Gallery Jeanne-Bucher Collection

PAGE 22:
The Optical Machine, 1937
La machine optique
Oil on canvas, 65 x 54 cm
Paris, Musée national d'art moderne,
Centre Georges Pompidou

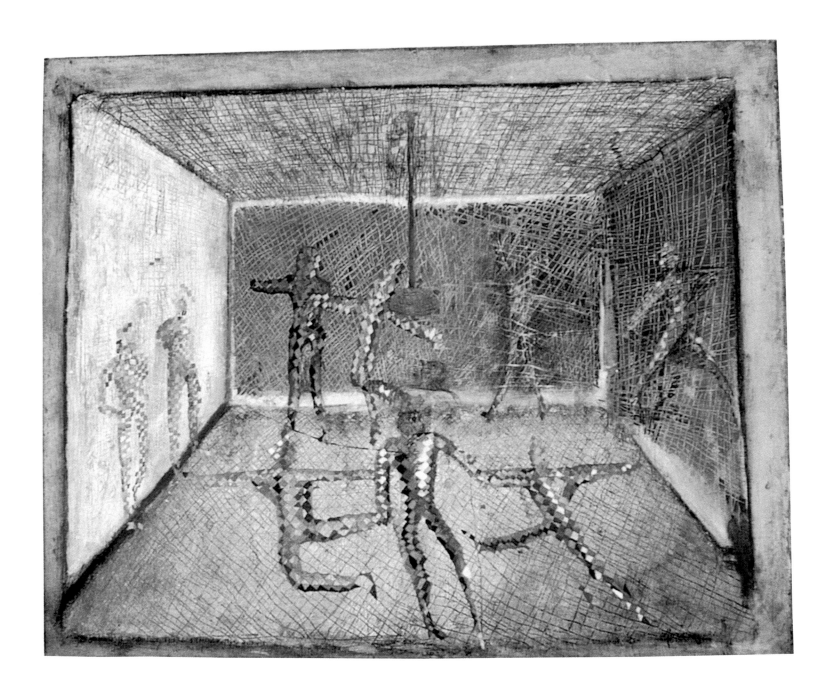

The Harlequins, 1939
Les arlequins
Oil on canvas, 46 x 55 cm
France, private collection

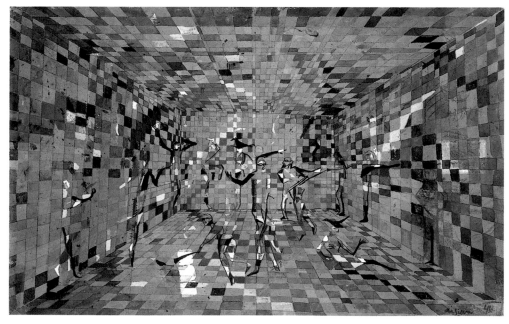

"Ballet" or "The Harlequins", 1946
«Ballet» ou «Les arlequins»
Gouache and pencil on paper,
49.5 x 80 cm
France, private collection

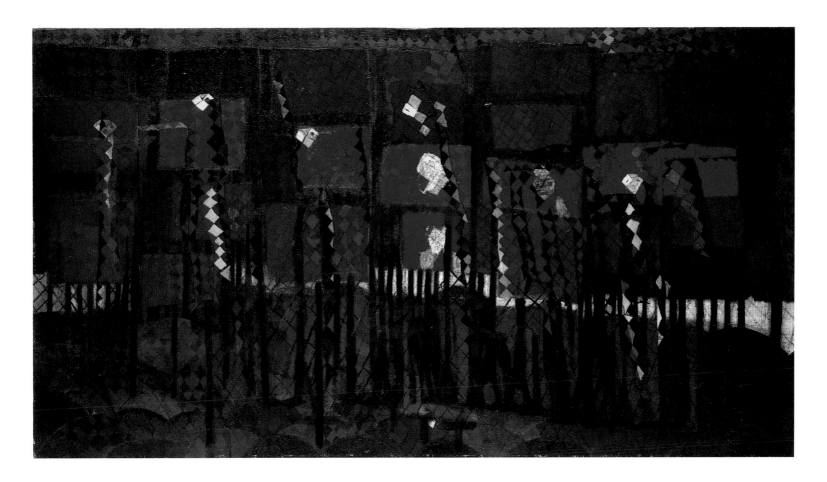

developed into a machine three levels high; once again, the movements of the human figures on the various levels are limited by strings. In the next two gouaches, the merry-go-round turned into a sort of spiral fish trap with several rings. Small human figures are tumbling free-fall through this device, which is suspended in the picture space. The last three related works bear the same title. *Freedom lies with us* (p. 11) identifies these first tentative attempts to depict the tragic relations of humankind with the spatial environment. Her works of those early years are marked by a conscious avoidance of virtuoso figurative representation, the conventions of which modernism found suspect. But they also maintained a distance from the experiments in form being undertaken by the Paris avant garde.

In a painting dating from 1931 and now lost (p. 12), which rendered the large swing bridge in Marseilles harbour with only a few lines, the artist concentrated entirely on spatial qualities. Black lines criss-cross the even, light surface of this second early large-format canvas. A straight line presumably represents the horizon, and above it, side by side, are two small, irregular quadrilaterals. Da Silva based the painting on sketches produced on the spot, and in the course of her work established a first synthesis of her spatial studies, which she herself recognised as "a direction, just beginning." The lines and "openings" (as she herself described the rectangular shapes, which are frequently interpreted as houses) are to be seen as echoes of a reality which is here presented as perceived from afar, from an immense height. In a pastel done the same year, *The Quay of Marseilles* (1931, p. 12), we are offered a view from above in which all that remains of the harbour road are a few outlines between which passers-by have shrivelled to tiny specks. Adumbrations of ships at anchor make it possible to identify the harbour she was painting from the high-lying room in

The Revolt, 1939
L'insurrection
Pencil on paper, 22 x 32 cm
Paris, Musée national d'art moderne,
Centre George Pompidou

The Red Flags, 1939
Les drapeaux rouges
Oil on canvas, 80 x 140 cm
Düsseldorf, Kunstsammlung
Nordrhein-Westfalen

Family Portrait, 1939
Portrait de famille
Crayon on paper, 21.2 x 31.5 cm
Portugal, private collection

Marseilles where she and Arpad spent a few days. The port inspired her to venture into the realms of abstract spatial representation.

During those years in Paris, Vieira and Arpad kept to a strict, self-imposed work routine. Only on rare occasions did they go out in the evenings to meet artist friends in the cafés of Montparnasse. In 1933 the gallery owner Jeanne Bucher, who had seen works by the artist couple in the annual Paris art Salons, organised da Silva's first solo exhibition. Together with some sketches, graphics, gouaches and oil studies, she exhibited the originals of her illustrations to a children's story she herself had written, *Kô and Kô, the two Eskimos*. A publishing house had rejected this story of two children's journey of initiation in quest of the sun as being "too apocalyptic". In the accompanying gouaches done in 1933 (p. 13) she reduced the figures and landscape to their bare essentials, like cut-out silhouettes. The illustrations again used a high vantage point, as if the viewer were looking from heaven down to earth in order to observe the two children. The pictures occupied a special place in da Silva's show, representing as they did a further step forward in her continuously advancing treatment of space.

In a little regarded picture dating from the same year, the artist sought to take stock after the exhibition. *Work* (p. 12) systematically represents the relation between space and figure which she was aiming at. It is a small oil sketch on canvas, with a crooked horizontal line dividing it and in turn crossed by vertical lines and diagonals criss-crossing the pictorial surface. These lines imply the perspective of a viewpoint above the picture, and define the proportions of the two schematic figures beneath the horizon. Two oval "openings" allow us to see into spaces subject to linear perspective. This composition was preceded by two studies, in which the standing and squatting figures in *Work* appear in isolation. *The Escapee* is crouching, bent over painfully, on a rectangular cage which contains a small sphere. He is entangled in the mesh of a net that forms the top part of the cube. His attempt to escape appears to have failed. *The Tree in the*

"The Messenger", or "The Hero", 1939
«Le héraut» ou «Le héros»
Oil on canvas, 46 x 65 cm
Lisbon, Centro de Arte Moderna,
Calouste Gulbenkian Collection

26

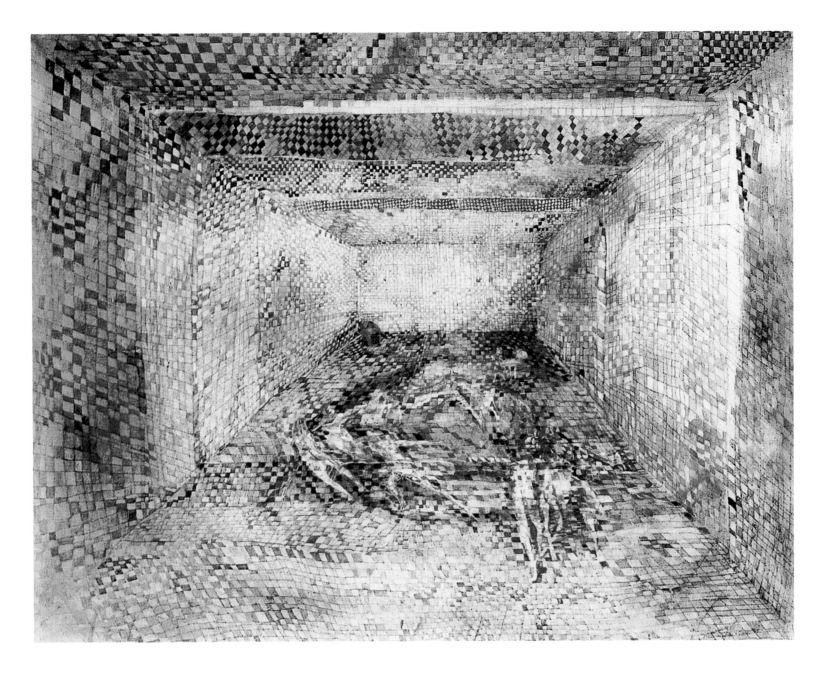

Prison (1932, p. 11) takes the figure with upraised arms and places it standing inside a cage. All the works feature spatial representation which suggests that our standpoint is located far out and above.

A large-format composition which da Silva worked on in Paris and Lisbon in 1934 and 1935 brought about a radical change in her approach to establishing space. In *Studio, Lisbon* (p. 16), using the converging lines of linear perspective, the artist takes the two-dimensional canvas, which had hitherto been the undefined painted surface of her spaces, and transforms it into a box-like space. The outer edges of this box coincide with the borders of the canvas. Da Silva paradoxically combines this return to the traditional scheme of linear perspective with the use of a purely abstract visual language, which she had rejected after her Marseilles venture, despite its actuality among her fellow artists. This was the first occasion on which she was prepared temporarily to abandon her figurative language: "I believed that one could say more with figurative painting, but people do not see the figurative elements in the same way as I do." Into this painting, she "put everything she loved", and in so doing transferred the problems of spatiality from the wide world out there into the microcosm of her own

The Studio, 1940
L'atelier
Oil on canvas, 73 x 92 cm
Portugal, private collection

27

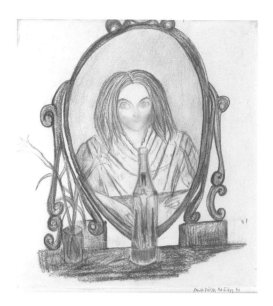

Self-Portrait at the Mirror, 1940
Autoportrait devant le miroir
Crayon on paper, 21.8 x 20 cm
Dijon, Musée des Beaux-Arts

Métro, 1940
Le métro
Gouache on cardboard, 47 x 97.5 cm
Lisbon, Metropolitano

working space. The clearly-defined borders of the studio space made it seem familiar and controllable; and indeed, concentrating exclusively on the structure of space by purely formal, pictorial means was liberating at first. In the following period of high productivity, the titles of her pictures indicate the direction her pictorial quest was taking: *Exploration of Space*; *Structural Study*; *Related to the Studio, Lisbon*; *Structure, Movement*; *Composition, In Quest of Structure*, and *In Quest of Composition* are the titles of her studies on the problem of spatiality.

Da Silva's long vacillation between figurative painting and abstraction, and her attempts to combine the two, remained definingly characteristic of her painting until the end of the 1940s. In that respect, her work absorbed and bodied forth a contemporary conflict that also preoccupied the Paris art scene. Between the wars, it was on this terrain that the two irreconcilable fronts, the advocates of realism and the supporters of abstraction, clashed. The 'Amis de Monde', a small left-wing group of intellectuals which the couple had joined in 1935, held weekly gatherings in the Café Raspail, where the threat of Fascism was discussed and divergences over realism thrashed out. Doubts concerning the legitimacy of the abstract formal idiom as a means of communicating with the public at large tended to prevail over purely aesthetic considerations on Vieira's side of the stand-off.

In 1935, following a severe attack of jaundice and while she was still weak and confined to her bed, the artist painted her room as it might be seen in a delirium. She dissolved the picture surface into tiny, vibrant rectangles of colour, and blurred the perspective definition of the pictorial space. There may be walls, floor and ceiling here, but they are destabilized by the absence of a solidly-defined spatial centre. *The Tiled Room* (1935, p. 17) is a prison from which there is no escape for our eye, which traces the receding and advancing contours over and over again. The repetition of a single formal element, which she had previously experimented with in

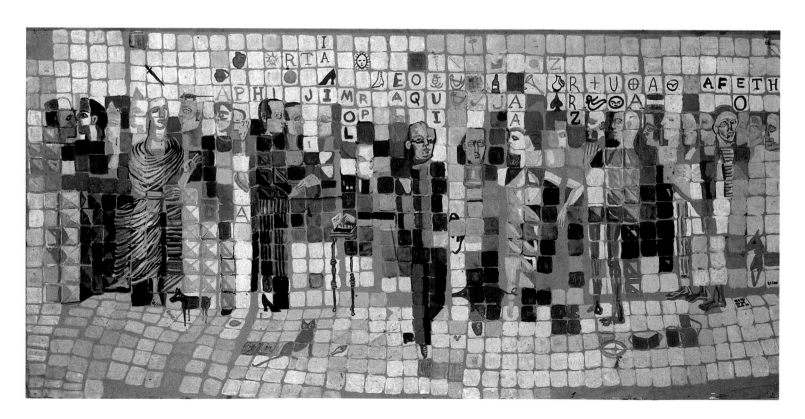

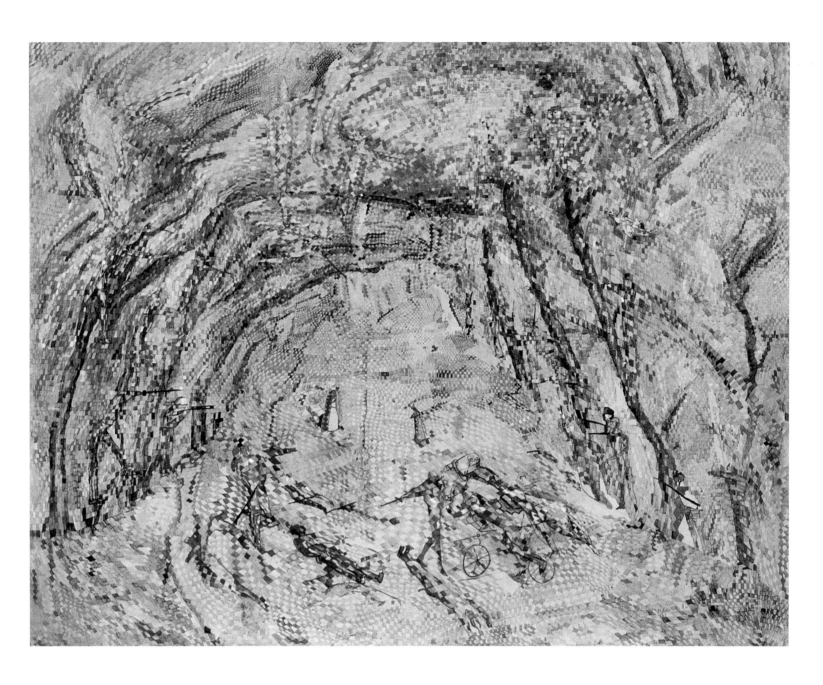

The Procession, was to be the second principle in her new approach to structuring spatiality.

Over the following months, she systematically deployed the various components of this new pictorial idiom. She made every effort to increase the spatial ambivalence and to free herself from the tyranny of the vanishing point, which she saw as a relic of a superannuated concept of space. It is possible to follow, step by step, her obsessive struggle to establish an autonomous spatiality in order to use it as the site of more complex pictorial situations. The converging perspective lines are recast as broad bands of colour which interweave to form a mesh suggestive of both depth and impermeability, in a striking untitled painting of 1935 (p. 18, bottom). A painting entitled *Composition* these bands combine with linked wall structures to create routings and reroutings of different colours, as the patterns return upon themselves, obstructing the spatial depth. In another painting also entitled *Composition* (1936, p. 18, top), the bands turn into paths in a tangled maze with no exit, suspended against an undefined pale blue background. The vanishing point in the centre, which seems rather lost, is a reminder of the basic principle of linear perspective. It has lost its

The Forest of Errors, 1941
La forêt des erreurs
Oil on canvas, 81 x 100 cm
USA, private collection

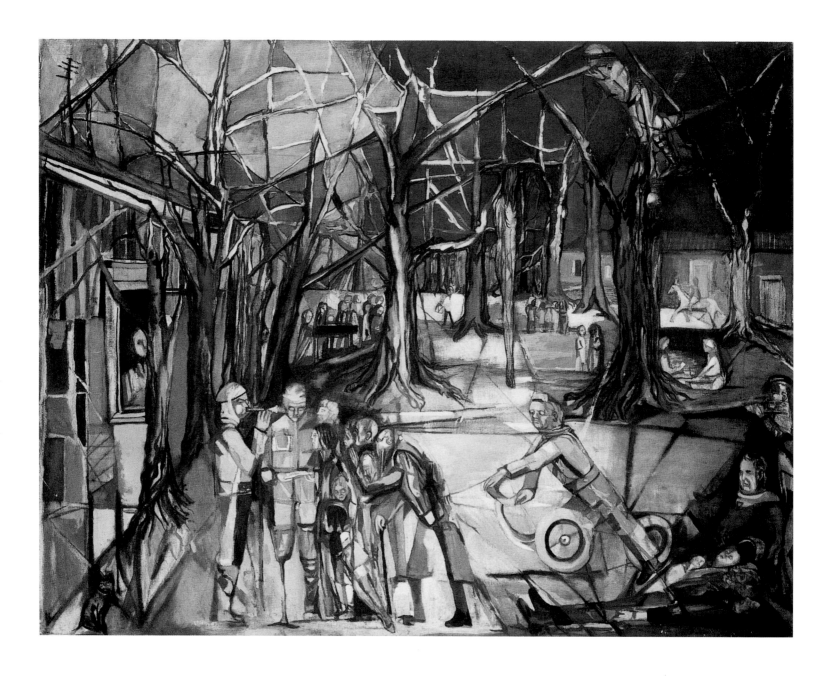

Calvary, 1942
Le calvaire
Oil on canvas, 81 x 100 cm
Paris, Musée national d'art moderne,
Centre Georges Pompidou

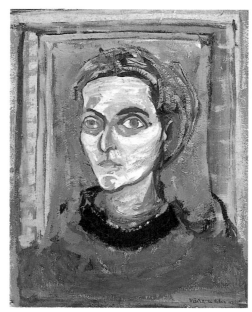

Self-Portrait, 1942
Autoportrait
Gouache on cardboard, 49 x 40.3 cm
France, private collection

Arpad, 1942
Arpad
Gouache on cardboard, 50 x 40.5 cm
France, private collection

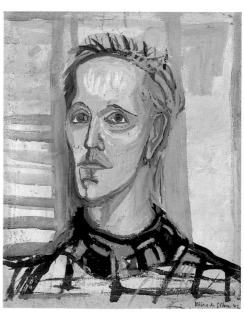

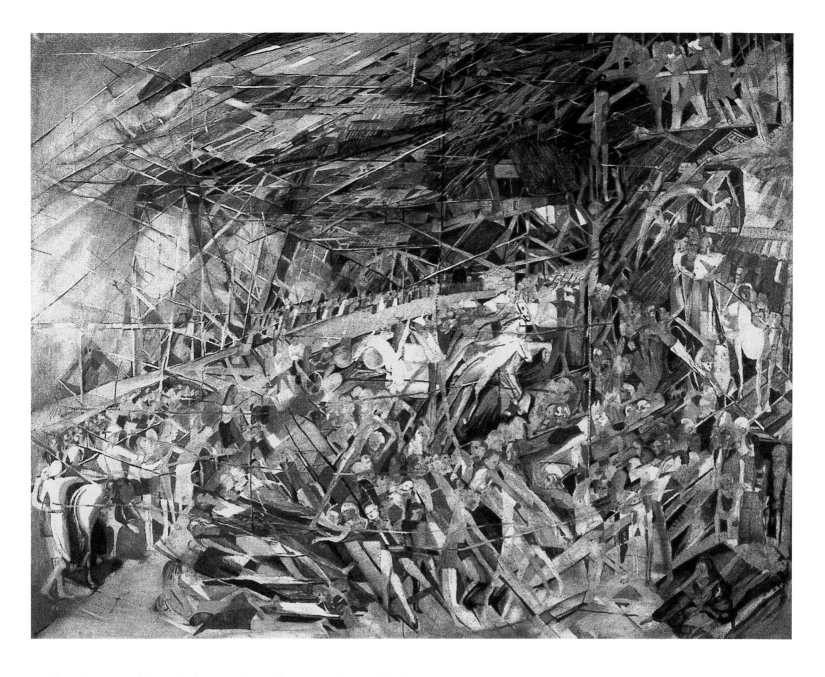

predominance without being replaced by any other unifying principle. What remains is a space that is inaccessible and is collapsing in upon itself. In a fourth picture, *The Lines* (1936, p. 19), the line becomes an autonomous, liberated element, repeating endlessly. The dynamics of the few diagonal lines that lead into spatial depth are broken up by parallel lines and gatherings of lines. The intensity of the shining oils reinforces the impact of the net-like structures and bars on the spatial effect. Thus in various ways, she takes spatial linear perspective *ad absurdum*. Its oppressive structures enclose a claustrophobic vacuum from which there is no escape. The hermetically scaled spaces, and the habit her routes have of returning in upon themselves, are symbolic of despair in general, and particularly of the hopelessness the artist sensed at this point in her work.

Da Silva's restriction of her work to spatial representation, with the concomitant exclusion of human figures from her paintings, brought with it the danger of moving further away from her pictorial ideas than she really intended. In this fundamental renewal of her art she felt thrown back on her own subjectivity. Da Silva felt powerless when confronted with the complexity of an uncertain world which could only be experienced and

"Disaster", or "War", 1942
«Le désastre» ou «La guerre»
Oil on canvas, 81 x 100 cm
Paris, Musée national d'art moderne,
Centre Georges Pompidou

portrayed in fragments. Confused, she stopped and broke off her investigations of spatiality in order to review once more what her goal in fact was. Her artistic reflections at this stage focused on a mythological figure, marking the return to figurative painting. On the work *The Siren* (1936, p. 20), childishly colourful capital letters surround the spirit of the waves out on the high seas. They form a passage from the close of Canto 1 of *The Lusiads*, the great epic by the Portuguese national poet Luis de Camões (c. 1524–1580):

> "Where is frail man to turn for succour. Where may he live out his brief span in safety, secure in the knowledge that the heavens will not vent their indignation on so insignificant an insect?"[4]

The figure and colours in this picture imitate one of the sirens depicted on a ceiling painting in the royal palace of Sintra; they are luring the sailors on board a caravel to a watery grave. When she was a child, Vieira would have looked up at them frequently. This figure is one that appears time

"The Conflagration", or "The Fire II", 1944
« L'incendie II » ou « Le feu »
Oil on canvas, 81 x 100 cm
France, private collection

and again in her paintings and drawings. In a small ink drawing she made in Lisbon in 1939, the artist drew a self-portrait underneath the siren, unambiguously indicating that she identified with this hybrid mermaid who was at home in two elements. In the 1936 painting, the siren is the artist's alter ego, a figure reflecting her own insecurity. She was afraid of losing her way as she journeyed into the unfamiliar world of pictorial space, and of missing her goal when confronted with the many options that her work displayed at this moment. But she was a well-read artist, familiar with mythology, and was also referring to the mythological dimension of this fabulous being whose pictorial call could lure man into another world. Would her new pictorial idiom, the beauty of her work, be as bewitching as the sirens' song? Would the new tool she had sought so long add enchantment to her pictures?

The Street, the Evening (1936, p. 21) was painted after she had resumed her explorations of spatiality. In this horizontal-format picture, the sightlines criss-cross, coinciding with lines and bands of colour and light at various levels. They form irregular grids or combine into squares, parallels and open spatial zones which feature schematically rendered figures or

"Tragic Maritime Story", or
"The Shipwreck", 1944
«História trágico marítima» ou «Naufrage»
Oil and pencil on canvas, 81 x 100 cm
Lisbon, Centro de Arte Moderna, Calouste
Gulbenkian Collection

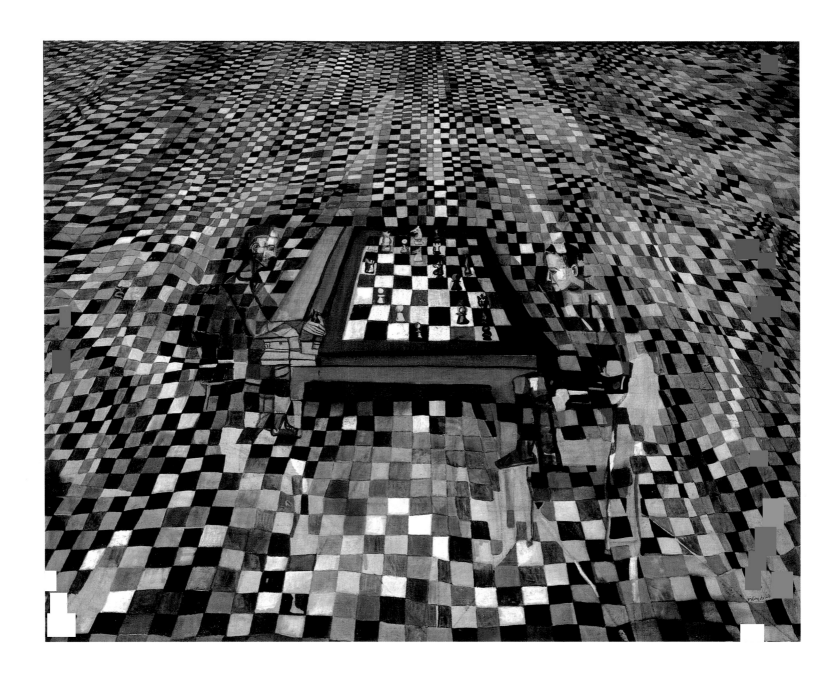

objects. We can make out passengers in a car, a cyclist, traffic lights, a pedestrian crossing and a head in an illuminated window. This composition was the artist's first attempt to integrate the human figure into the picture space she had established. It was a hermetic space with no exits in which the artist had entrenched herself, and only now did it come into its own as the spatial *sine qua non* of human existence. It is in the meeting of space and figure, abstraction and figurative painting that the latent conflict between tradition and modernism is apparent in da Silva's work. And this encounter shows her ambition to reconcile the polarized opposites.

The space in "*La Scala*", or "*The Eyes*" (1937, p. 23) is enclosed by walls that are densely studded with eyes. The title of the empty visual theatre we are looking at recalls the great opera house of La Scala in Milan. The eyes crowd around, staring back at us. It is an inexorable gaze from the darkness on the other side, the same that has given the scale (*escala* is Portuguese for "scale") for scenes such as *The Swings*, *The Swing Bridge*, *The Escapee* and *The Tree in the Prison*. Even after da Silva revised her concept of space, this perspective used in earlier works

continued to apply. In an ink drawing dating from 1939, the paper is filled with a network consisting of eyes which mesh together to form something resembling an insect's compound eye. A somewhat larger pencil drawing mutates the eyes to the close holes of a net in which a human figure is caught. *Man Trapped in a Net* (1939) confirms the sense of being inescapably surrounded which was previously created by the watchful eyes in "*La Scales*", or "*The Eyes*". As in *Work*, the true subject of these pictures is a view of the world from a vantage point far outside.

Lozenge- or diamond-shaped areas of various colours cover the low, horizontal-format space in *Lozenges,* or *The Dance* (1938). The format recalls *The Street, the Evening*. At several points the pattern condenses to form figures dancing diagonally across the stage. Harlequin figures appear to emerge, only to be swallowed up again. This ambivalent connection between the human figure and space was to be the actual challenge da Silva's art faced over the following years. Oils, gouaches and drawings all examined in their various ways the symbiotic relationship between the theatrical space, made up of more or less complex lines, networks and

PAGE 34 TOP:
The Game of Chess, 1943
La partie d'échecs
Oil and pencil on canvas, 81 x 100 cm
Paris, Musée national d'art moderne,
Centre Georges Pompidou

PAGE 34 BOTTOM:
Memory of Lisbon, c. 1943
Evocation de Lisbonne
Ink on paper
(lost)

Liberation of Paris, 1944
Libération de Paris
Oil on canvas, 46 x 55 cm
France, private collection

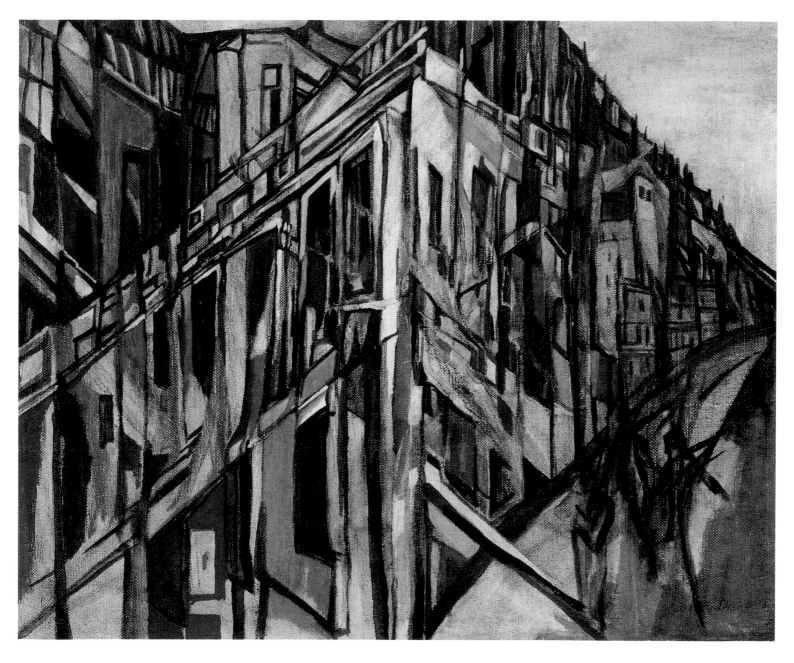

35

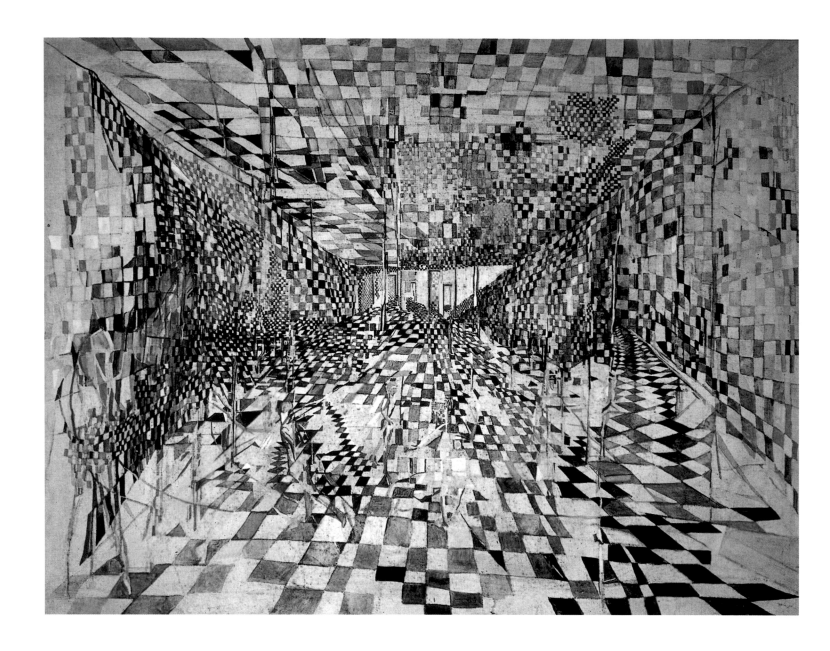

Enigma, 1947
Enigme
Oil on canvas, 89 x 116 cm
Porto, João Vasco Marques Pinto
Collection

rhomboids, and the human figure within it. In *"The Messenger"*, or *"The Hero"* (1939, p. 26), a knight and his counterpart float as colour projections over the black barred walls of a cage suspended in the picture space. The protagonists' winding paths leave trails. The stage, which until now was always hermetically sealed, opens at the rear on the intensive blue surrounding it. One of the trails leads out into this infinity of colour. Dancing *Harlequins* (1939, p. 24) become entangled in the web of lines which constitutes the stage. These elements of space take on a life of their own in *The Revolt of the Bars* (1939, p. 25): here, the lines, colour rectangles and rhomboids quit their traditional positions and create a spatial absurdity in which small human figures vainly attempt to combat the prevailing arbitrariness. They are at the mercy of its superior strength, with no hope of escape.

This series of pictures, which to this day shines with the intensity of an obsessive quest, peaked and achieved a first culmination in 1940 in *The Studio* (p. 27). It is a large painting in which da Silva deployed her artistic repertoire with supreme ease and confidence. The stage area has become one of vast depth. There is a dizzyingly dynamic movement in the walls, floor and ceiling of this long corridor, which is "papered" with hundreds

of tiny squares matching each other perfectly in colour. Human figures are on the floor of this stage, moving in a round dance, making expansive and expressive gestures. A couple facing us are leading the dance. As in a puzzle picture, we occasionally feel we have managed to pick out and define the shapes, if just for a moment, but their outlines are then lost again in the general spatial oscillation. Two figures which are greatly scaled down are engrossed in a game behind the dancers. To the rear of the stage, the artist has portrayed herself in the characteristic, high-backed wicker chair which Arpad often painted her sitting in. Her figure is highlighted by the only red splashes of colour in the entire composition.

Her limiting herself to working out her own spatial structure had begun five years earlier with her retreat from the world into her own studio. In this programmatic synthesis of space and figure, the return to her workplace presented her very own vision in direct contrast to the world. In the first self-portraits, the artistic self was looking out of the picture into the world. The self was defined by the picture space and its concerns indicated in the darkness of the unknown behind it. From 1934/35, space became independent. At the same time it became a hermetic, sealed-off factor, returning endlessly upon itself, circling its own despairing emptiness. On this depressing stage with no way out, human existence became a transitory projection. The world was devalued, read as a mere semblance. Humanity left no more than a faint trail in it. And this brings us back to the 1940 painting *The Studio* (p. 27), in which the artist at the outermost edge of the stage is the only figure to possess any three-dimensionality. Between her and us as viewers, the dance or game is a *teatrum mundi*, the theatre of the world, and the director of the play – the artist – is sitting on the periphery, watching the performance from afar. At the beginning of the Second World War, during the first stage of her exile and thus at a time when she had lost her social sphere and any ability to play a meaningful part, Vieira resignedly accepted the loss of the world, which had long been her theme, as a breach between self and world. In her view, life in the great world theatre was a devalued phenomenon, a passing moment.

Dancing and game-playing, the two metaphors of human existence which Vieira was presenting in *The Studio*, were also homages to Cézanne and Matisse[5]. These two great examplars, who had defined figurative painting and abstraction as opposite poles in modern art, showed da Silva the way to her own pictorial world, which she saw as a synthesis of what had gone before. During the course of her obsessive quest for unknown space, she was also aware of coming close to her Portuguese roots, which only began to bear fruit once she was abroad: "I went to Paris for purely intellectual, not practical, reasons. People have always set sail from the port of Lisbon, out into the world, in order to populate it. In Paris, one discovers that wide world everywhere one goes. And Paris then peoples space with inventions. If I had not come to Paris at precisely that point in time, I would not have been able to continue working. I needed *the tool* with which one can press on ahead into unknown space, and that I could only find in Paris."

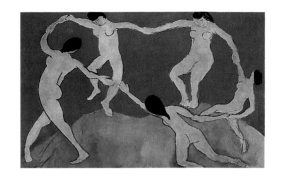

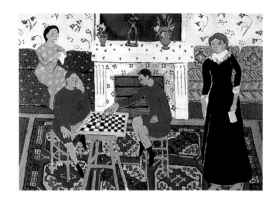

Henri Matisse
The Dance, 1909
Oil on canvas, 259.7 x 390.1 cm
New York, The Museum of Modern Art

Henri Matisse
The Painter's Family, 1911
Oil on canvas, 143 x 194 cm
Leningrad, Hermitage

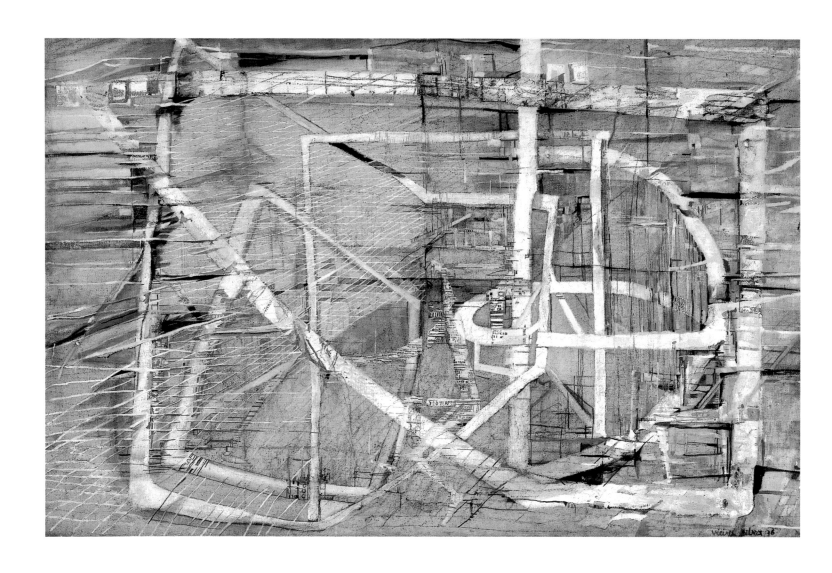

Exile
Rio de Janeiro 1940–1947

When the War started, Vieira and Arpad were spending the summer with friends on the Ile de Ré in western France. Being a stateless Hungarian Jew, Arpad was particularly anxious that the conflict would spread. Immediately after the outbreak of war, in September 1939, the couple left their new studio in the Boulevard St. Jacques in Paris. Da Silva spent nearly a year in Lisbon unsuccessfully attempting to regain her Portuguese citizenship, which she had lost when she married a foreigner. The regime of the dictator António Salazar did not grant her various applications, as Arpad was suspected of being a Communist. She was told that she would only be given Portuguese papers if she got a divorce. As news of the course of the war steadily grew more alarming, the two artists decided in June of 1940 to go to Brazil. Although they had no difficulties in understanding the language of their country of exile, and although they soon, thanks to recommendations from Portuguese friends, became acquainted with artists and writers in Rio de Janeiro, da Silva never managed to shake off a feeling of uprootedness throughout their seven years of exile. It very soon became clear that they would not be able to support themselves in Rio de Janeiro through the sale of their avant–garde works. The art scene in the Brazilian capital was conservative, and figurative art remained dominant there. In order to overcome their financial difficulties, Arpad took on a series of commissions to paint portraits and started giving art lessons in 1944, while Vieira helped by painting vases, plates and tiles.

"We made unforgettable friends in Brazil [...] We were very happy, even though we enjoyed no recognition whatsoever as artists. Only artists who were themselves outsiders valued our work." Thus her summary of those years, revealing just how much she suffered from the hostility with which she was met by the public and critics. In Lisbon and Paris there had been an interest in the exhibitions at which her works were shown from 1935 to 1937. She was quite unprepared for the rejection, partly polemical in tone, of the exhibitions of her work organised by friends in Rio de Janeiro's National Museum (1942) and the *Ashkanazy* Gallery (1944). Her doubts about her own work multiplied. Mutual acquaintances put her in touch with Torres García, a Uruguayan artist whose work she had come to know and respect in Paris in 1930. When he received photographs of her works in 1943, he published an enthusiastic article about them in his native country. She wrote him a letter of thanks in which she

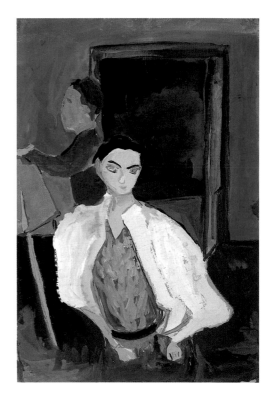

"Family Portrait", or *"The Studio, the Couple"*, 1930
« Portrait de famille » ou « L'atelier, le couple »
Gouache and pencil on cardboard,
60 x 40 cm
Lisbon, Fundação Arped Szenes –
Vieira da Silva

PAGE 38:
The Weavers, 1936–40/48
Les tisserands
Oil and ripolin on canvas, 106 x 162 cm
Paris, Musée national d'art moderne,
Centre Georges Pompidou

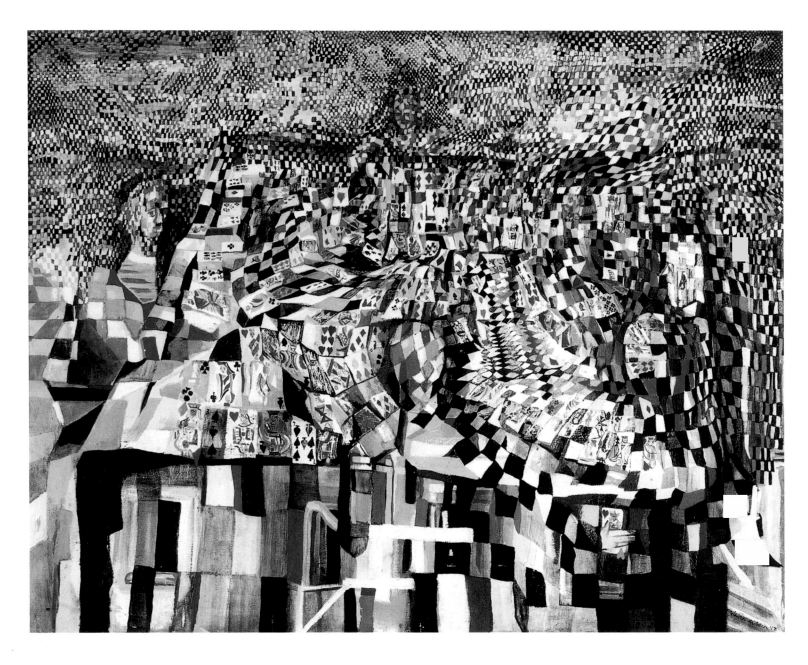

The Card Players, 1947/48
Les joueurs de cartes
Oil on canvas, 81 x 100 cm
France, private collection

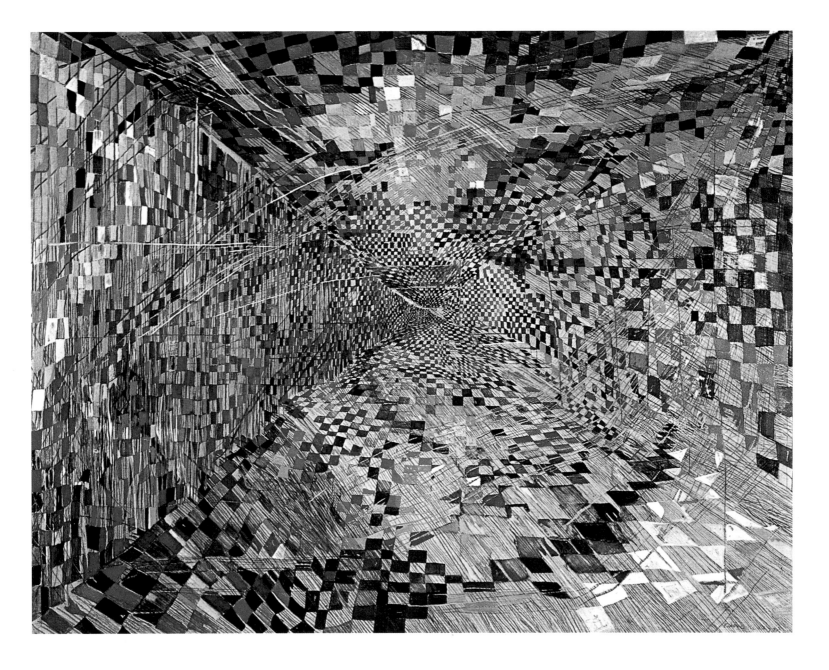

observed, "art is something terrible. I face great difficulties in my work, which goes very slowly. Frequently I am totally disheartened. At those times I secretly read your article and regain my courage."

Da Silva's first Brazilian drawings and gouaches were attempts to find her feet in her new surroundings: views of Rio, sketches of their rented rooms, a few self-portraits and portraits of their writer friends Murilo Mendes and Cecília Meireles and the artist Carlos Scliar. Lisbon proved an inexhaustible subject, and in working on it she was attempting to assuage her yearning for her native country. She appeared herself as a young girl or a siren (1936, p. 20) in front of the silhouetted city, as if to show the beholder the way. But all her thoughts were of the war. Filled with anxiety, she would await the news from Paris, which would then have a strong effect on her mood for the rest of the day. Drawings such as *My Mind was Full of Sad Thoughts*, *Killed in Action*, *The Field of the Dead*, and the small oil painting *War*, recorded her first reactions to the reports made by other exiled Europeans. In a small self-portrait dating from 1940, she painted herself reflected in an oval dressing-table mirror, and in front of the mirror, hidden behind a bottle, a tiny crucifix. Its

Endless Corridor, 1942–1948
Couloir sans limite
Oil on canvas, 81 x 100 cm
Switzerland, private collection

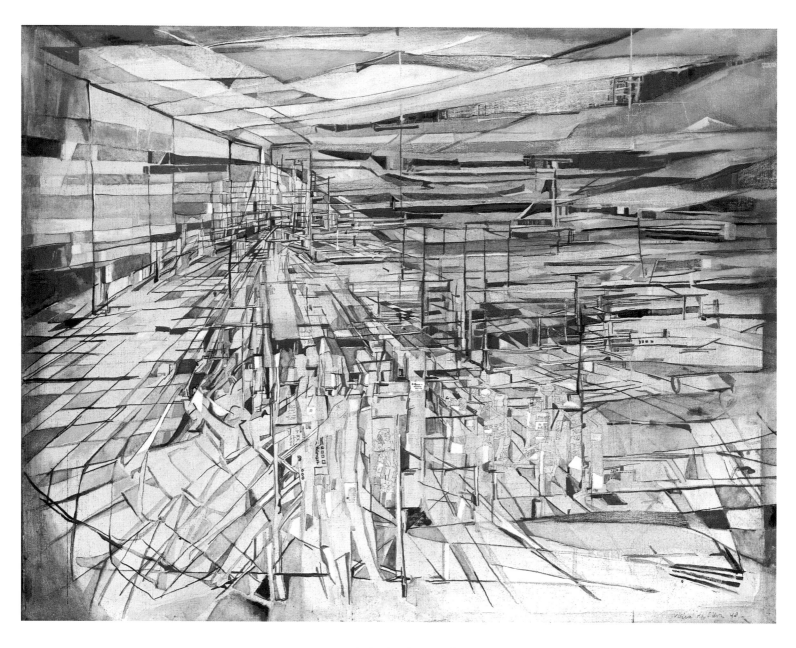

Egypt, 1948
Egypte
Oil on canvas, 65 x 81 cm
Paris, Musée national d'art moderne,
Centre Georges Pompidou

cross was right in front of her heart, which contained, in an altogether
Romantic spirit, all the fearful conflict of the world. Da Silva herself did
not see her geographic remoteness from the events of the war, and her
inner distance from the world, as any kind of flight from reality: "People
frequently say that artists live in ivory towers", she observed. "I think
I am quite different; my life is quite the opposite. I feel that everything
happening in the world is falling upon me with such violence that it
almost drives me mad; do you understand what I mean? I do not need
to leave the house […] it was the same when I was a child. I experienced
all the events after the 1914 war very intensely." She succeeded in sub-
limating her constant feelings of anxiety into a fully individual empathetic
suffering, grieving both for and with the torn world. The split of her self
from the world was offset by these feelings of empathy and consternation.
And her identification with the misfortunes of war once again strengthened
the figurative components in her painting.

Soon after the first air raids on Paris she painted *Bomb Shelter* (1940,
p. 28), which in its fashion essayed a symbolic rescue of western culture
from its imminent destruction. Da Silva's thoughts were particularly with
the people of Paris, taking refuge from the bombs in the Métro, and so the

canvas became a frieze of figures and fragments inspired by Portuguese tile panelling. A year later she worked on a large oil composition which derived its spatial concept from a drawing she had done of a leafless avenue of trees near Rio. "The title, *Forest of Errors* (1941, p. 29), is that of a sixteenth century Portuguese book, and it is a truly beautiful title," she noted. "At that time I was thinking a lot about the men in the Maquis hiding in the forest. Error was their only chance of survival. But I was also thinking of Cézanne's landscapes." The picture is alive with restless white and green iridescence. Armed soldiers can be made out between the tree trunks and the greenery in the avenue. A cyclist is riding amongst the dead. Two men are engaged in a sword fight. There is the figure of a queen, and all manner of other shapes, which we lose from sight amongst the irresoluble spatial entanglements. The confounding game extends even to the treetops on the left, which merge to form the gigantic shape of a woman. She is bending protectively over the entire scene, and in sheer scale she dwarfs the other protagonists to miniatures. In this dark forest of disorientation and confrontation, neither time nor space can be precisely defined. At the bottom of the avenue there is a pale, luminous opening

The Basement, 1948
Le souterrain
Oil and pencil on canvas, 81 x 100 cm
France, private collection

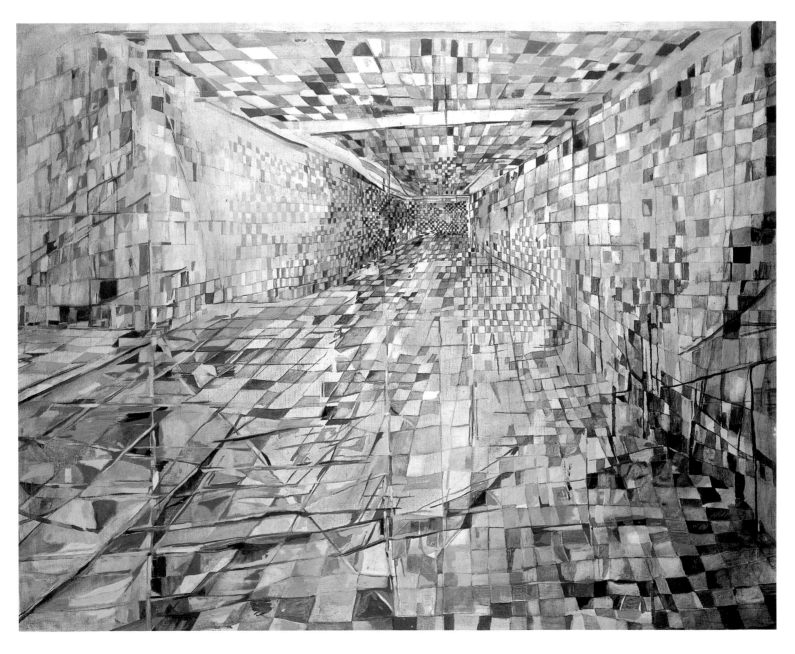

guarded by the figure of a tiny girl: a glimmer of hope, announcing the end of these terrible ordeals.

In the painting *Calvary* (p. 30), dating from 1942, da Silva even abandoned her new concept of space. She drew upon Christian iconography in order to record the horror she was feeling. It shows scenes of war in a field hospital overarched by a dark night sky with a lattice of bare trees criss-crossing before it. The figure of a hanged man takes centre place on this Golgotha. The surprisingly Surrealist atmosphere was already evident in the preparatory drawing *Public Park*; the monstrous bird creature in the tree alludes to the visionary art of Hieronymus Bosch. When she was young, da Silva had spent time in the National Gallery in Lisbon, engrossed in Bosch's *The Temptation of Saint Anthony* and its strange, fabulous creatures. "I wanted to paint the misfortunes of war, but I simply did not know how to paint it," recalled the artist. "My thoughts kept returning to it, but I was unable to make any decision. And then, one day, a Polish woman came to see us. She told us how she had escaped Warsaw with a friend in a car. Her only child, a paratrooper, had been killed in action. She told us all kinds of details about the war, about all the people, horses, refugees, the dead. She told us what had happened in a station that had

Library, 1949
Bibliothèque
Oil on canvas, 114 x 146 cm
Paris, Musée national d'art moderne,
Centre Georges Pompidou

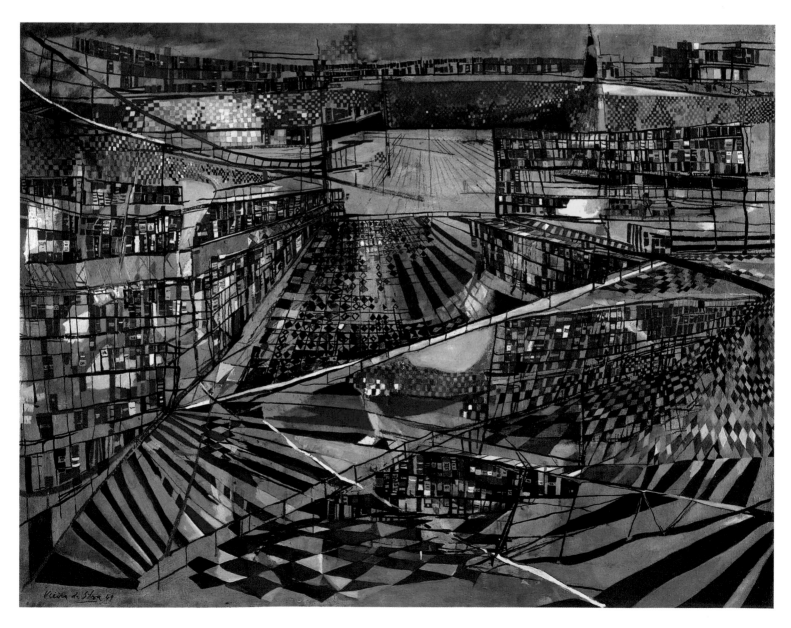

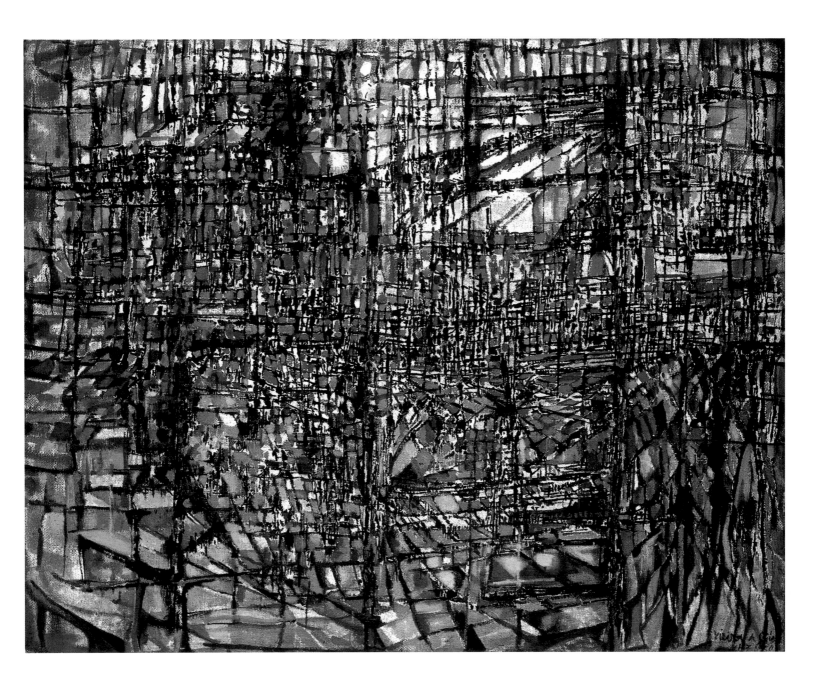

been destroyed by bombing, the panic amongst soldiers and civilians. Her descriptions gave me the idea for *"Disaster"*, or *"War"* (1942, p. 31). This authentic eye-witness report from the war zone freed da Silva's empathetic imagination. She mourned the disastrous grief brought by warfare, much like the figure in black robes in the foreground of the composition, in the classical attitude of mourners. The spatial perspective she used in the work went back to a small drawing entitled *For a future picture*, which she had done in Portugal in 1939. The dominating parallel lines converge on a single, tiny point of exit. The coloration, principally in shades of brown and ochre, the high horizon, and the juxtaposition of a broad variety of scenes, all recall Brueghel's *Triumph of Death*. Vieira was putting herself into the role of witness, in the tradition of the great painters who had seen or envisioned the horrors of the Inquisition, the epidemics and the military conflicts which afflicted Europe in the sixteenth century. She had seen Brueghel's painting in 1931 on a visit to the Prado in Madrid. The horses, riders and the forest of bayonets are also reminiscent of the great battle scenes painted by the Italian artist, Uccello. The leafless branches

The Big Building Site, 1950
Le grand chantier
Oil on canvas, 81 x 100 cm
Turin, Museo Civico de Arte Moderne

45

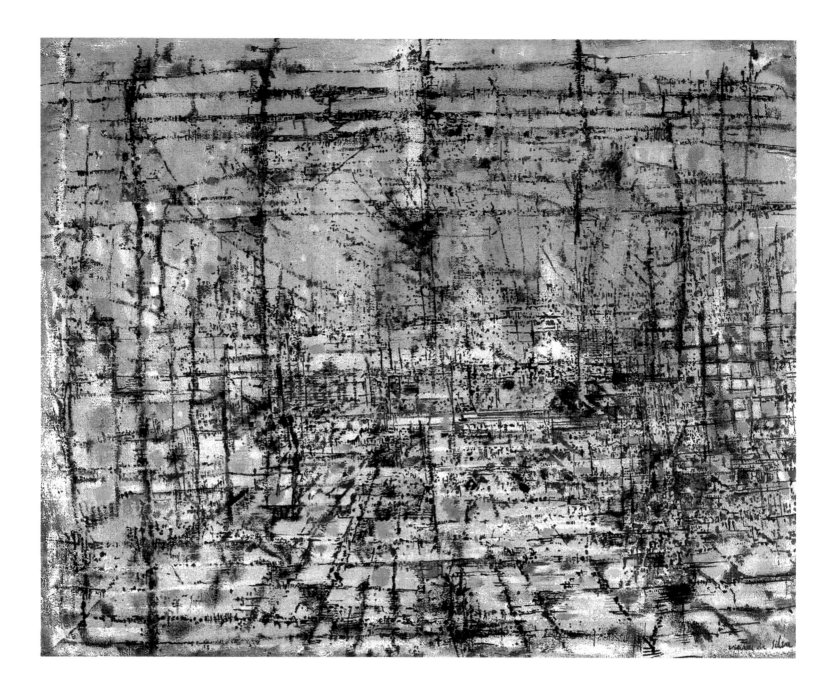

Gare Saint-Lazare, 1949
La gare Saint-Lazare
Oil on canvas, 60 x 73 cm
Paris, Gallery Jeanne-Bucher Collection

from *Public Park* have now become the irregular, skeletal vault over
the station, which itself appears to be revolving around the vertical axis
of a rope in its centre. The people in this scene retain their individual
dignity, despite the teeming masses around them. Their gestures are elo-
quent of individual suffering and terror, and at the roof window they are
symbolic of farewell; countless faces are paralysed with fear. The relent-
less rhythmical and formal styling of the human bodies reduces them
to little more than puppets, anticipating the formal simplification of the
playing card figures in later paintings, and emphasises their utter and
inescapable involvement in the space in which they are meeting their fate.

Da Silva herself felt that this painting had taken her to the limits of
what she was capable of painting. "This picture is a kind of interpolation,
standing outside what I usually paint. I wanted to be a witness of the
events, in opposition to war. When I painted *Disaster*, it was as if I
were crying out against absurdity. Afterwards I realised that I could not
continue on this path. I thought: 'I must give pleasure to others. There
is so much misery, so much sadness, so I will give joy.'" But the global

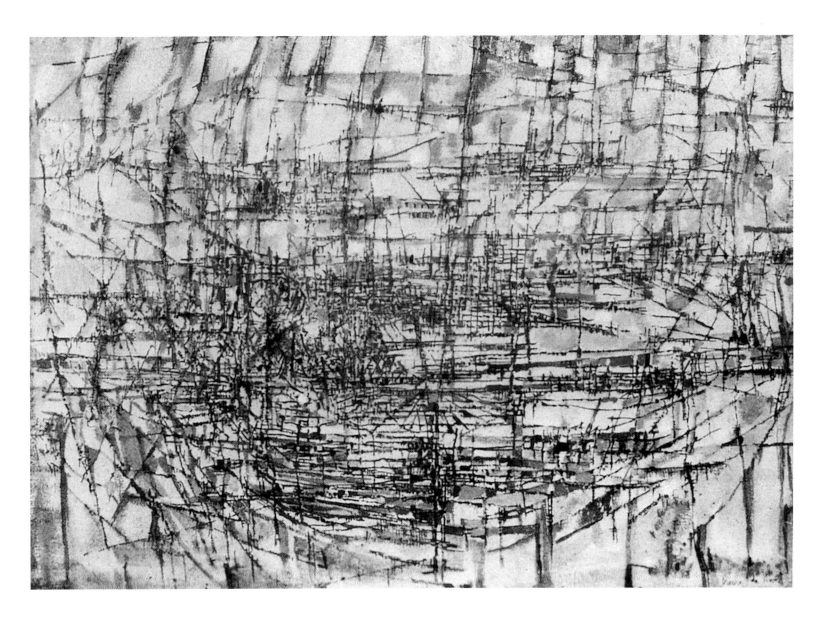

catastrophe then taking place chimed so entirely with her own fundamental sensibility that she found herself committed, bound to struggle further with the subject. Her personal anxieties combined with examination of frightful events, and, for the first time, entered into her art unimpeded. She rehearsed individual episodes of the war in her drawings. In 1944 the world went up in flames in her paintings *The Fire I* and *The Fire II* (1944, p. 32). In these pictures, trees metamorphose into human figures, human arms become branches, branches are transformed into animals, and the conflagration consumes all. The axis of the composition is formed by the white figure of a woman floating above the flames, like a radiant head of Medusa. This figure was prepared in a small drawing, *Will-o'-the-wisp*. The Surrealist scene, attempting to convey an unbearable reality in nightmare form, is set against a dark background. A similar effect is achieved in "*Tragic Maritime Story*", or "*The Shipwreck*" (1944, p. 33), in which a towering, foaming wave is breaking while out towards the horizon the ocean seems calm and dark. The wave is a monster threatening to swallow the fragile boat and its shipwrecked occupants, who are fighting the waves. She was no longer painting the war, but instead drew upon one of the seminal, almost mythical texts about the Portuguese voyages of discovery as a timeless metaphor of destructive natural catastrophes.

The Spider's Feast, c. 1949
Le festin de l'araignée
Oil on canvas, 89 x 116 cm
Brazil, private collection

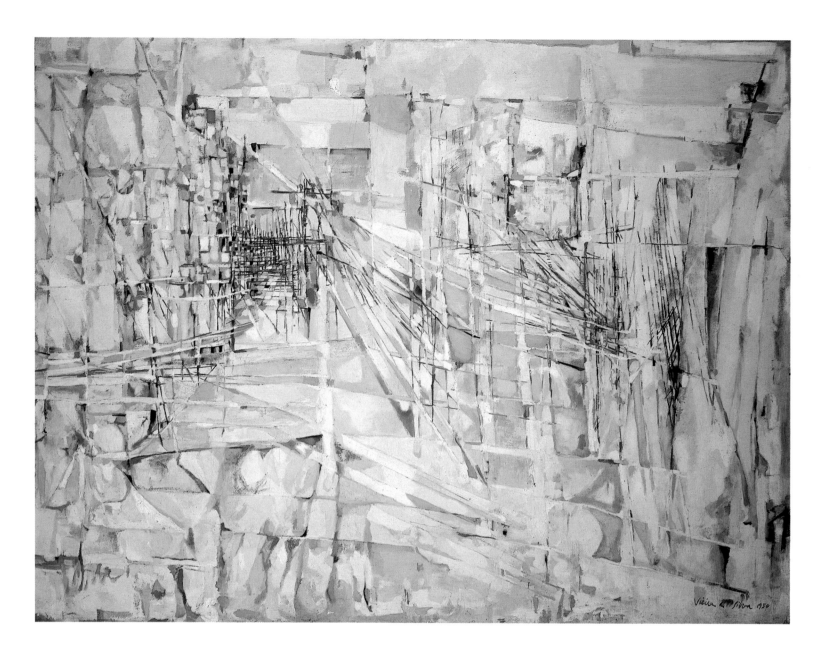

"Entrance to the Castle", or "Homage to Kafka", 1950
«*L'entrée du château*» ou «*Hommage à Kafka*»
Oil on canvas, 89 x 116 cm
France, private collection

In the same year, she produced a painting anticipating the *Liberation of Paris* (1944, p. 35). The colours of the Tricolor, visible on a few façades, make little impression on the sombreness of this compact city scene. To the right, the buildings recede, opening to our view a stretch of road and a patch of sky, which is growing brighter on the horizon. The outlines of three figures can be made out against the houses. They are standing at the foot of a crucified figure, a shadowy projection on the buildings. The painting features an emphatic vertical axis, beside which figures seem to be dropping in free fall into the depths. This image of a tormented city continued da Silva's enquiry into the questions concerning fate and destiny first raised in her series, *Freedom lies with us*.

In these disaster pictures, she practically forced figurative elements into her spatial system, despite the formal strains that this involved. She tightened the tension created by the latent contradiction between the real space, represented, and space as an abstract entity in her art almost to breaking point. Another subject area enabled her to develop her rendering of spatiality still further.

Playing chess and cards, music and readings had become daily activities for Vieira and Arpad during their years of exile, distracting them

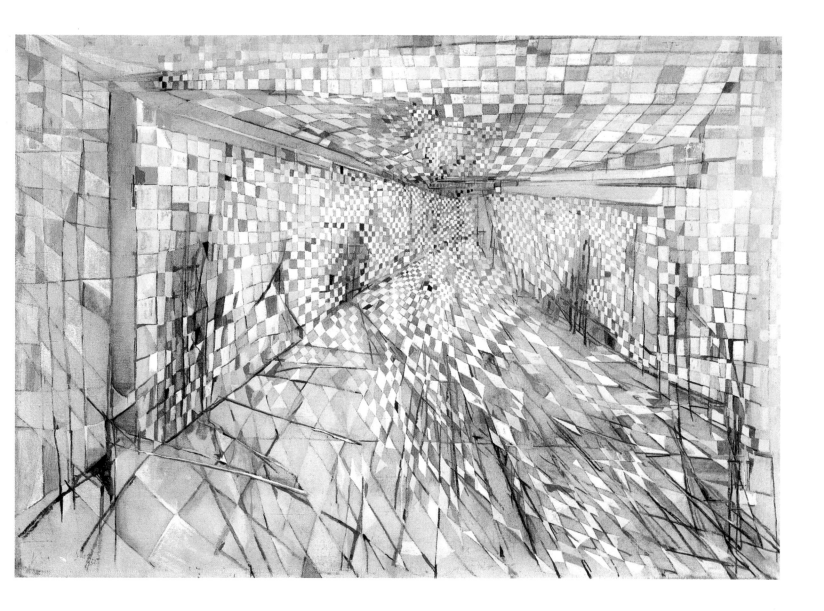

Grey Room, 1950
Chambre grise
Oil on canvas, 65 x 92 cm
London, Tate Gallery

from worries and thoughts about what was going on elsewhere. From 1940, the chess board, the harmonium and the library started to play a part in various sketches and studies. The painting *The Game of Chess* (1943, p. 34) emancipated the motif from the realm of the merely anecdotal. The scene is viewed from above; we see a tiled floor, extending over the entire picture surface and apparently sinking away to the left and right, and the scene as a whole tends toward a vanishing point which takes us beyond the margins of the picture into infinity. The converging perspective lines start outside and underneath the picture. The hermetically sealed space around the picture thus becomes a borderless plain open on all sides, cropped and curtailed by the edge of the picture alone. In the centre of the scene, a clearly defined table stands on this disconcerting floor. The chess board on it matches the perspective and pattern of the tiles. The figures of the chess players themselves are formed out of tiles of different colours; in contrast to the room and table, the players appear to be seen from the side, almost from below. "I thought about *The Game of Chess* for a long time before I started the picture. The ideas were gestating in me for a long time. I had a notion of what I wanted to do, but I then drew some small squares and the players appeared of their own accord. They emerged from the background and I was satisfied for them to do so. It was not what I intended, not what I expected, but this time I was content because the

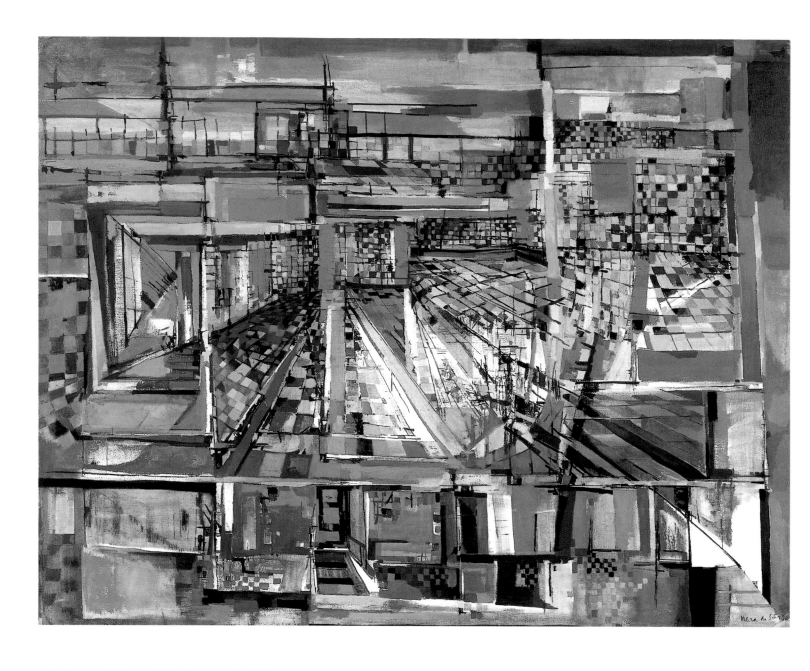

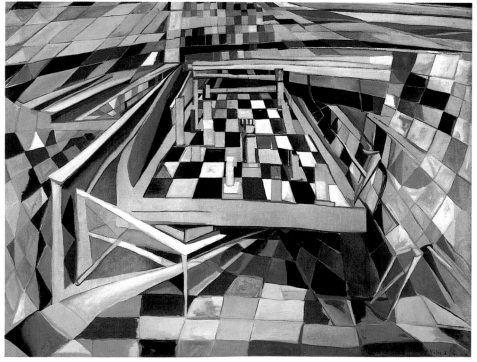

The Invisible Walker, 1949–51
Le promeneur invisible
Oil on canvas, 132 x 168 cm
San Francisco (CA), San Francisco
Museum of Art

Check and Mate, 1949–50
Echec et mat
Oil on canvas, 89 x 116 cm
Lausanne, Alice Pauli Gallery

picture seemed to me to be more spacious and broader than what I had conceived." Two players at a chess board in a huge room whose walls lie outside the borders of the picture. But this spaciousness does not free the two players from the prison-like atmosphere we are already familiar with from earlier paintings. The immense emptiness of this borderless room takes our breath away. It is dizzying. The claustrophobic space mutates into its extreme opposite, an agoraphobic infinity, becoming a threat to man, paralysing him. In his critique of the painting (which was exhibited in Rio in 1944), Murilo Mendes saw *The Game of Chess* as the meeting of antagonistic powers and orders in this world: "Are these two people or two machines? Are they deciding the outcome of a chess game or the fate of the world? The two red marks in the foreground highlight the realistic component, bloody onslaughts, and perhaps offer the key to the secret […] It is not just in the Escorial, in Cairo, London and Strasbourg that kings and bishops, knights and pawns are being moved – pity us, these two drops of blood – for it is happening all over the world."[6] Da Silva's space had broadened into a world stage. The game had become deadly serious and, move by move, humankind was at stake.

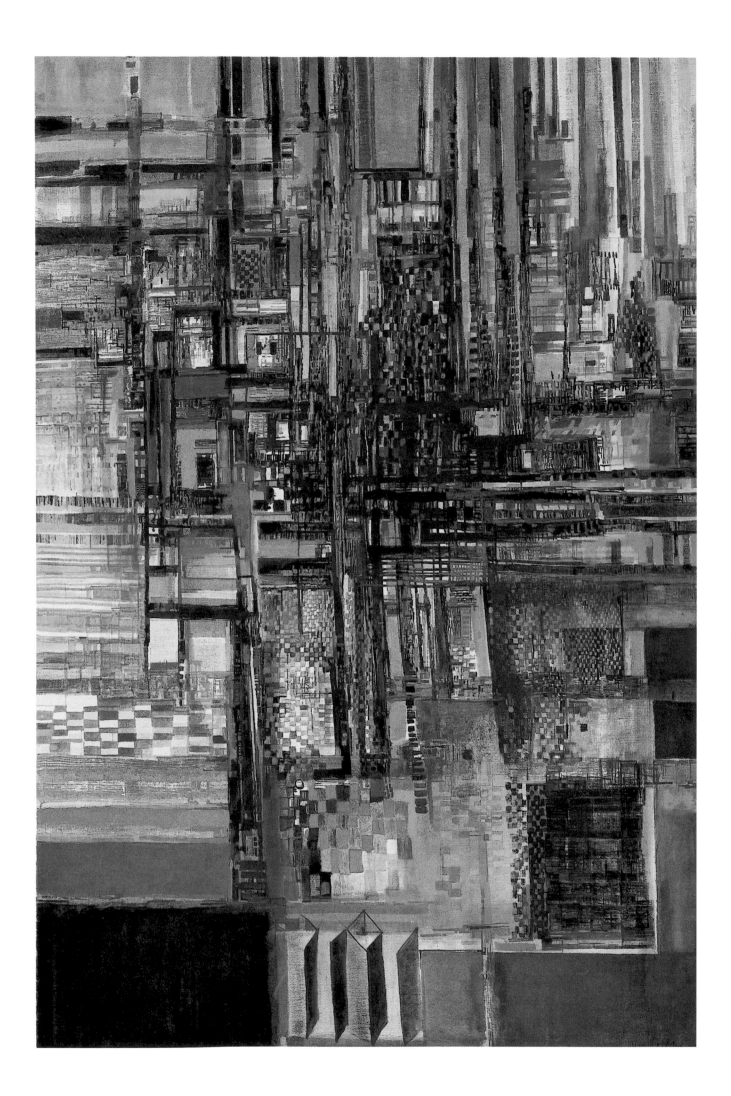

The Labyrinth
Paris 1948–1992

"For 40 years I have been searching for the same thing, and still I have not found it. I have no right to say what I am looking for. It is something precious which must blend with my painting in such a way that it becomes visible. If I were to talk about it, some people would think I was absurd, others over-anxious, and yet others too ambitious. So it is better not to talk about it prematurely…"

VIEIRA DA SILVA

Vieira and Arpad settled permanently in Paris after returning from exile. The city was to be their home for the rest of their lives. As before the War, their everyday routines alternating between their studio and flat, were entirely governed by painting. As Vieira said, with some surprise: "We led lives like bank clerks, at least in respect to the regularity of our working hours." From 1947, the two Paris galleries of Jeanne Bucher and Pierre Loeb regularly exhibited her work to an ever-growing public; and from 1950 onwards her painting achieved international recognition. The steady stream of exhibitions at French and international museums and galleries continued unabated throughout the years until 1992. Every year the two artists spent a few weeks in Portugal, living and working in her mother's house. The only regular breaks they took from their work were holidays in France. Otherwise, they only left Paris to participate in the opening of da Silva's exhibitions throughout the world. "I hardly go out of the house," she commented on her Paris life, "and take scarcely any interest in everyday matters…" She did, however, permit a small circle of friends, including poets, writers and young artists, to penetrate this barrier of self-imposed isolation. In 1954, Guy Weelen, later one of her historiographers took on the task of organising the public side of the two artists' work, thereby protecting Arpad and Vieira from anything that might have disturbed their concentration on their creative work. The couple moved to the rue de l'Abbé Carton in 1956, where architect G. Johannet had built them a new house and larger studios. Then Guy Weelen discovered a large country house, 'La Maréchalerie', at Yèvre-le-Châtel, where they spent the summer months from 1960 onwards. There was a generously sized studio in the garden of the house, affording them both enough room to continue their work without interruption by those undesired guests whose number had been increasing in Paris thanks to the greater public recognition da Silva now enjoyed.

One might describe the evolution of her artistic work from 1947 onwards as an upward spiral. She returned at intervals to the themes and formal approaches she had adopted in earlier works, updating them in new versions. Her entire oeuvre developed as a sort of work in progress, in which all the paintings were mutually dependent and connected to each other. For this reason, the particular point in time at which specific paintings were done became less important. The "painter of a single picture, conquered anew each day"[7] herself emphasised the inner unity of

Urban Perspectives, 1952
Perspectives urbaines
Oil on canvas, 97 x 130 cm
Great Britain, private collection

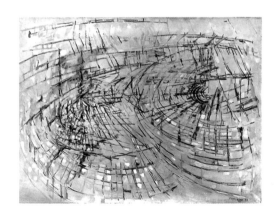

The Traces, 1953
Les pistes
Oil on canvas, 89 x 116 cm
Lisbon, Jorge de Brito Collection

PAGE 52:
Little by Little, 1965
Au fur et à mesure
Oil on canvas, 195 x 130 cm
Lisbon, Jorge de Brito Collection

53

her works: "Ever since my youth, themes have kept recurring, albeit with some differences. It is true that there is no progress; sometimes, however, we achieve a state of grace." A thematic preoccupation was evolving in her art which had been present in the very first works: "What I did later was already implicitly present in the earlier works. Those things existed as desires... Perhaps I did not pursue some directions far enough. Today, I see some of my canvasses as necessary studies..." When asked what the starting point of her pictures was, she once replied: "Frequently one of my old pictures that I would like to paint again." Even after the War she was dogged enough to persist in her tussle with spatial representation, undisturbed by the fact that this concern was manifestly at odds with the art of the period. "Perspective captivated me... To succeed in encapsulating a whole space on a small piece of canvas! But that is at odds with the rules of pictorial representation and the laws of a certain age...". Being thrown back on her own devices, her futile attempt to find a place in the world had been reflected in her hermetically sealed, linear perspective *Teatrum mundi* of the Thirties. During the period of exile, the identification of her own suffering with the conflicts that tormented the world was expressed by means of the symbiotic relationship of space and figure: thus she tried to overcome the feeling of being effectively sealed off. In the years after

White Composition, 1953
Composition blanche
Oil on canvas, 97 x 130 cm
Basle, Emmanuel Hoffman Foundation,
depository of the Kunstmuseum Basel

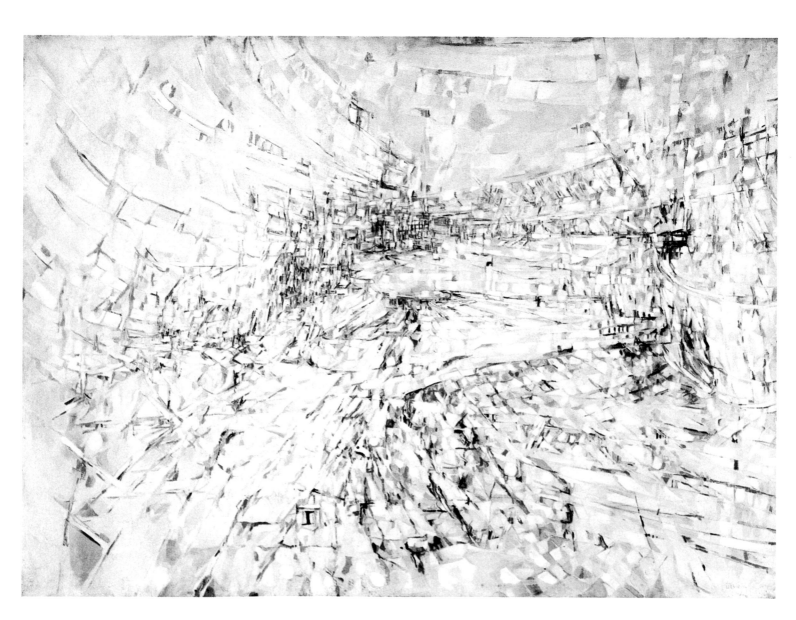

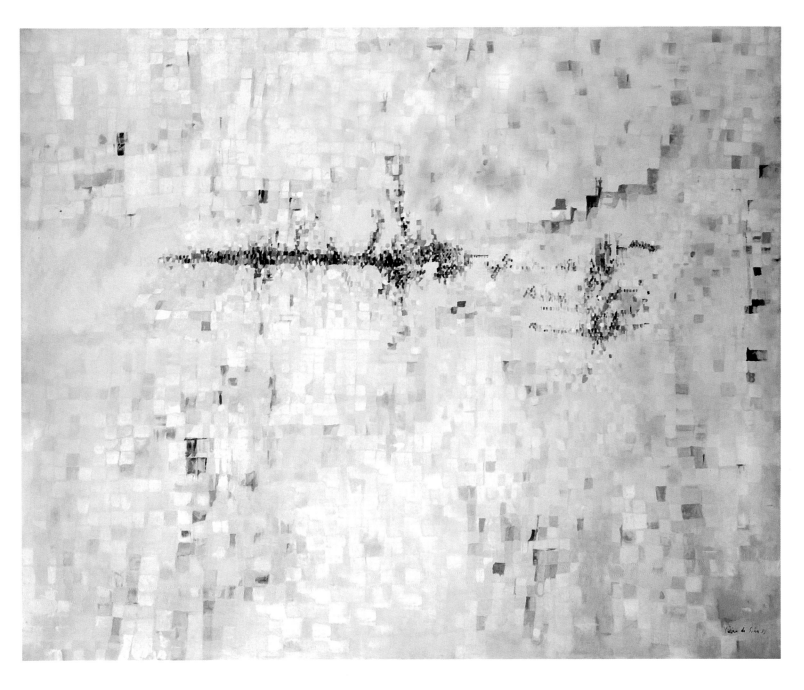

"Composition 55", or "Composition", 1955
«Composition 55» ou «Composition»
Oil on canvas, 116 x 137 cm
Paris, Gallery Jeanne-Bucher Collection

the War, by multiplying the spatial perspectives to create a new, bewildering diversity, she gradually transformed pictorial space into a symbol of the forlornness and lack of orientation of modern man. Each and every individual now stands at the "crossroads of perspective… Nowadays, we live as if we were nailed to the cross of perspective"[8] – thus da Silva explained the existential dimension of her concept of space to the art historian José Augusto França in 1963.

Over the years, that new space acquired a life of its own. Within it, her own experiences, literary affinities and analogies, myths and scenes from the modern age became variable constituents that were grouped and regrouped in ever-new juxtapositions. Memory continued to be the fertile soil that gave strength and fibre to her art: "I used to believe I had total recall, but I now notice that I forget many things, though other things still seem as if they had happened yesterday. It is a present that remains present." Her paintings developed a growing affinity with her vision as a seventeen-year-old, in which her meditations both on herself and on the world had become tied in an indissoluble unity. Since her earliest years,

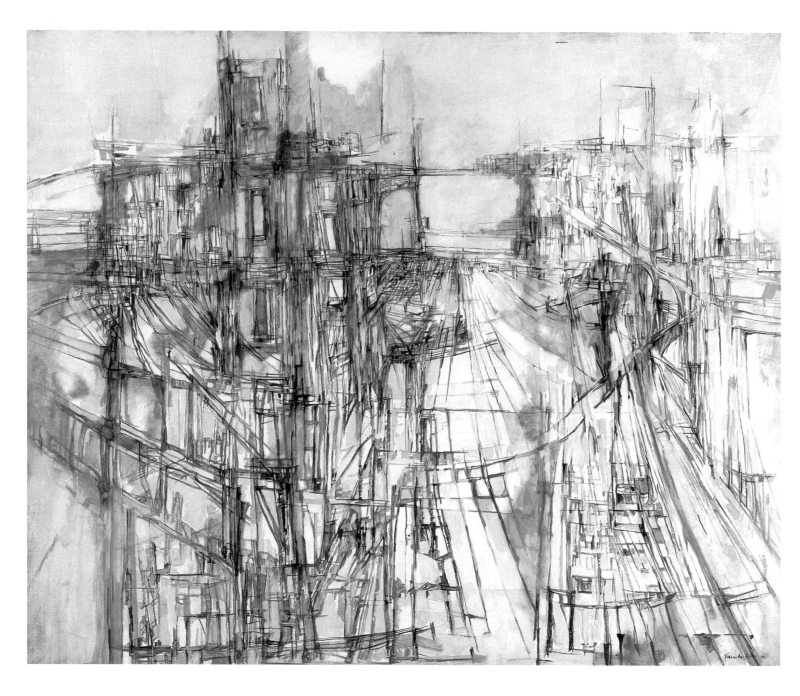

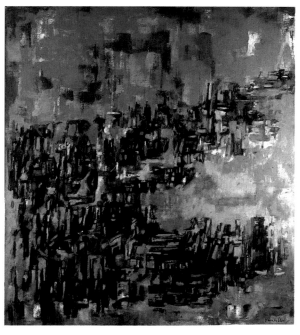

The Big Buildings, 1956
Les grandes constructions
Oil on canvas, 114.5 x 137 cm
Paris, Musée national d'art moderne,
Centre Georges Pompidou

London, 1959
Londres
Oil on canvas, 162 x 146 cm
Lisbon, Fundação Arpad Szenes –
Vieira da Silva

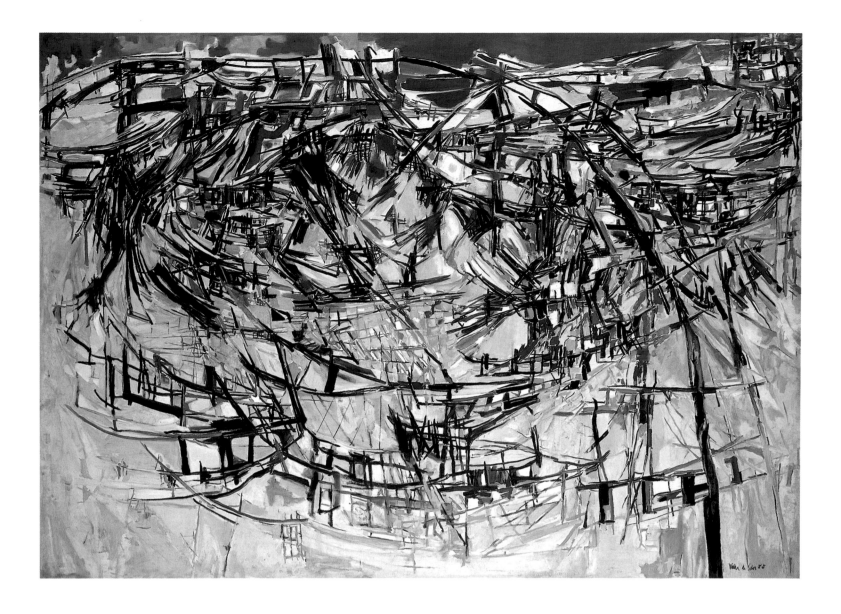

The Monorail, 1955
Le métro aérien
Oil on canvas, 160 x 220 cm
Düsseldorf, Kunstsammlung
Nordrhein-Westfalen

she had evoked the world through symbols to vanquish the horror of death and render its radical strangeness and mystery more familiar. Even as a child she had delved into the mythic, "which reifies what on principle is impossible to objectify, since its discourse is 'of the unworldly as worldly, of gods as human'"[9], in order to extend the "bounds of its rational potential"[10]. In da Silva's artistic self – image of her youth, this first appeared in a personal, figurative narrative style which needed decoding. Thus we see a little girl climbing to heaven on the biblical Jacob's ladder, in order to reach her father's world. The need to convey the heart of her imaginative world impelled the young artist to convert items of visible reality – such as the merry-go-round or the Marseilles swing bridge – into scenes which aspired to create an image of the Platonic myth of the other world. The title *Freedom lies with us* (inspired by a film by René Clair) lays open the reference to the story of souls that can freely choose their earthly destiny from the three Fates before falling to earth[11]. It was not until after the War that Vieira continued this "metaphorical dialogue" with the world, "even if the metaphor does not always have this kind of clarity and cogency…"[12]. Drawing on the repertoire of western myths and on empirical reality, she found analogies for an image of the world which had been taking shape since her earliest experience of transitoriness. In choosing the "absolute metaphors"[13] which her painting sought to

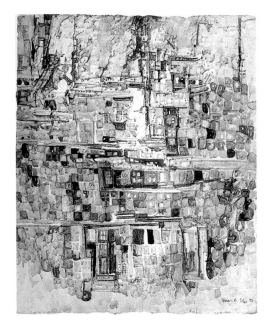

"Troglodytes", or "Old Walls", 1956
« Troglodyte » ou « Les vieux murs »
Oil on canvas, 63 x 50 cm
Paris, Musée national d'art moderne,
Centre Georges Pompidou

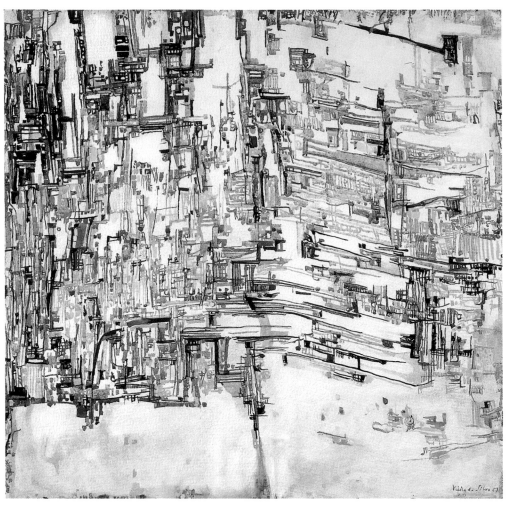

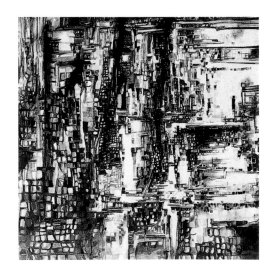

Workers' District, 1956
Cité ouvrière
Oil on canvas, 80 x 80 cm
France, Collection Louis Darinot

"Triangular City", or "The White City", 1957
« Ville triangulaire » ou « La ville blanche »
Oil on canvas, 69.5 x 70.5 cm
Dijon, Musée des Beaux-Arts

articulate, she used the same principle of appropriation that had been characteristic of the evolution of her formal idiom throughout: "I take what I need wherever I find it…" She was a well-read eclectic, as familiar with the works of Plato, Aristotle and Aeschlyus as she was with the Bible and contemporary literature[14]; her titles frequently gave the first clues to the bearings she was taking in a world she herself had created out of hetero-geneous components. She did not title her pictures out of a fear of the "unknown or non-defined"[15], as Eduardo Lourenço has assumed. Rather, the titling was a conscious act of mediation between the picture and the viewer. "Titles are a particularly painful problem for me," she admitted. "It is not we but the public who consider the name of a work to be import-ant. The title of a book is not everything!" she complained. In the same interview with Anne Philipe, Szenes' reference to the term for a painting that she had just finished indicates how she saw the status of titles: "*Spirals* faithfully reflects what you were trying to say." Wherever metaphors of language are used, they can point the way in communicating the picture's message – though on their own they will never exhaust it.

In general, the deeper layers of meaning of da Silva's works grew an increasingly spiritual protective carapace; in her view the "ability of painting to take on the maturation of life"[16] and "the confusion of the things of the world" were only to be "intuited from a distance". She concealed the "complexities of reality" (in Hegel's phrase) amidst the "essence of beauty and the nature of art", in the conviction that "a real piece of art is absolutely irrefutable and can conquer even the most

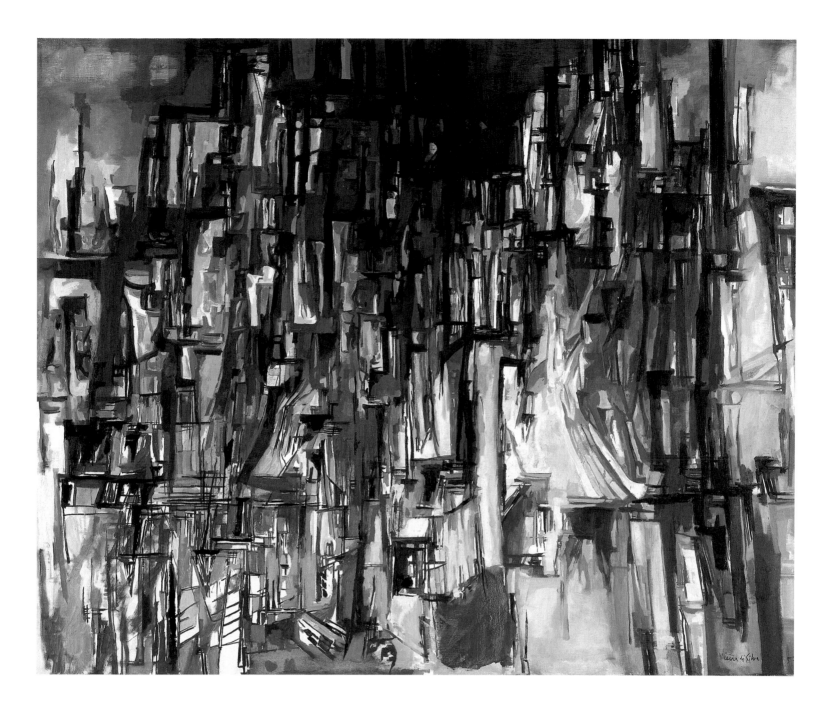

resistant of hearts". The formal development of her work from paintings determined by spatial perspective, via others emphasizing discontinuous space, to spatial constructs suspended in front of the unchanging background of a bright colour, increasingly broken up by light, showed da Silva constantly inventing new guises for the innermost being of her art[17].

The first paintings of the post-War years continued her experimentation with closed-off, elongated stage-like spaces. The walls became stable in *Endless Corridor* (1942) and *Grey Room* (1950, p. 49). The hermetic structure is relaxed by the mixture of colourful squares, lines and hatchings. In *The Basement* (1948, p. 43) and in *Entrance to the Castle,* or *Homage to Kafka* (1950, p. 48), da Silva opened the claustrophobic spaces, redoubling the dominant vanishing point thus weakening its impact. In its place, a disorientating choice of paths leads our eyes in various directions. At the end of the corridor in *Enigma* (1947, p. 36), which is split into several passages, doors and openings indicate a suite of invisible rooms. The very first canvas which she painted after her return from Brazil (*The Doors*,

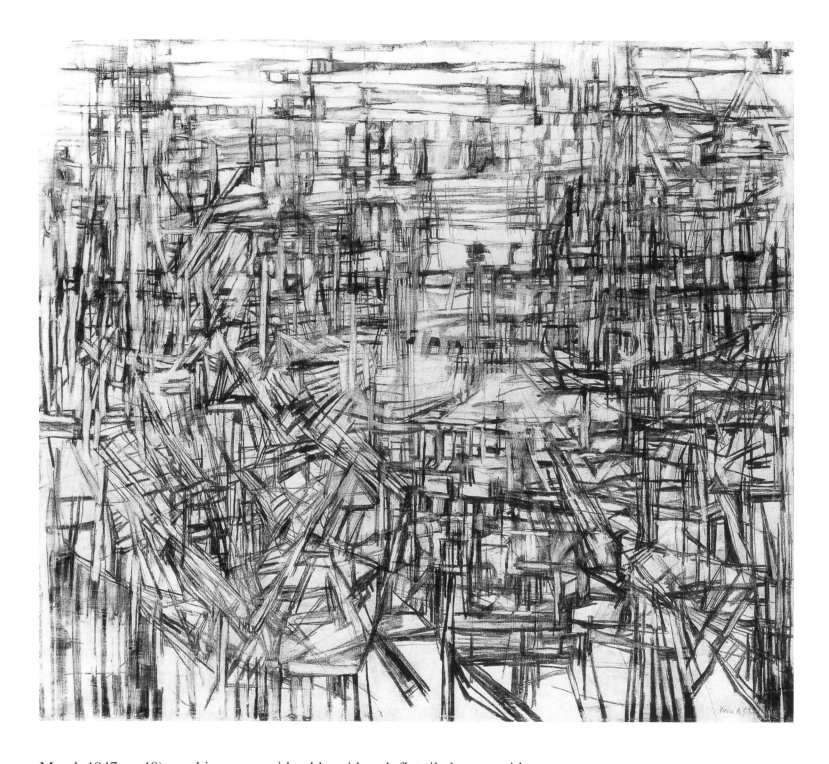

March 1947, p. 40) combines a considerably widened, flat tiled room with a long series of closed doors along its rear wall. This theme of her early work recurred in 1972 in *Thirteen Doors* (p. 76), albeit in a formally altogether different fashion. Some of the doors are now open and lead out into an undefined brightness. In these paintings da Silva was not only deploying the metaphor of the door as the entrance to another space beyond the world, but was also playing on the large number of possible paths, some tortuous and deceptive, that may lead there. In remaining on the knife-edge, the threshold between two spaces, she gained an extended conceptual space for her art. The *Teatrum mundi* opened out into the universe.

In *Egypt* (1948, p. 42), the picture space mutates into an articulated spatial construction: it is still an interior space of some kind, but it is now a building with various overlapping storeys and corridors, and the lines of perspective are in an unstable state of flux. A couple is hesitating, faced

Structures of the Future, 1959
Structure de l'avenir
Charcoal on canvas, 146 x 162 cm
Zurich, Kunsthaus Zürich

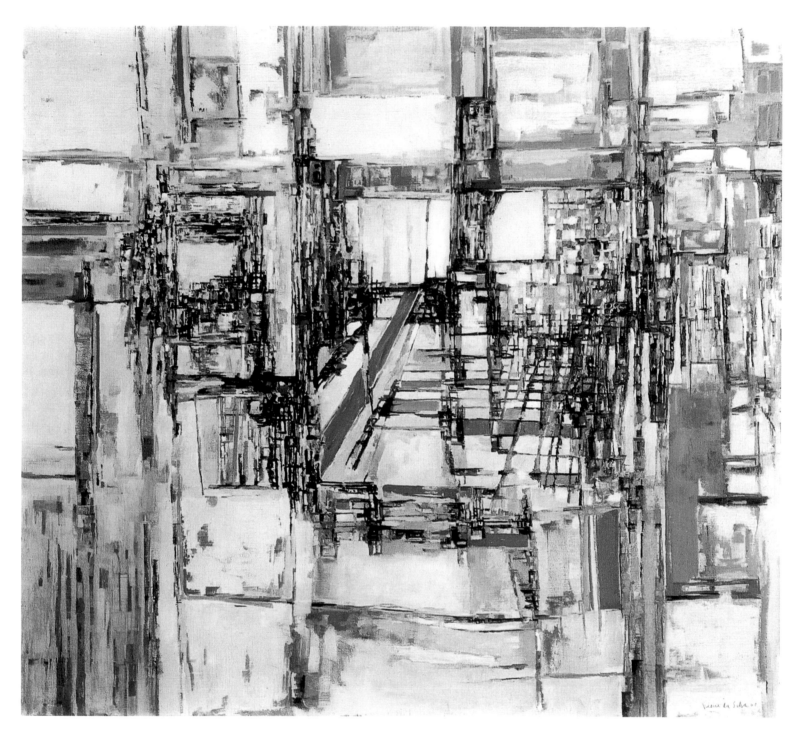

The ball, 1959/60
Le bal
Oil on canvas, 147 x 162 cm
USA, private collection

The Lost Path, 1960
Le chemin perdu
Oil on canvas, 81 x 100 cm
USA, private collection

The Fortified Town, 1960
Ville forte
Oil on canvas, 162 x 146 cm
Lisbon, Fundação Arpad Szenes –
Vieira da Silva

The Cycle of the Seasons, 1960
Le cycle des saisons
Oil on canvas, 81 x 100 cm
Lisbon, Centro de Arte Moderna,
Calouste Gulbenkian Collection

"Summer", or "Grey Composition", 1960
«L'été» ou «Composition grise»
Oil on canvas, 81 x 100 cm
Paris, Musée national d'art moderne,
Centre Georges Pompidou

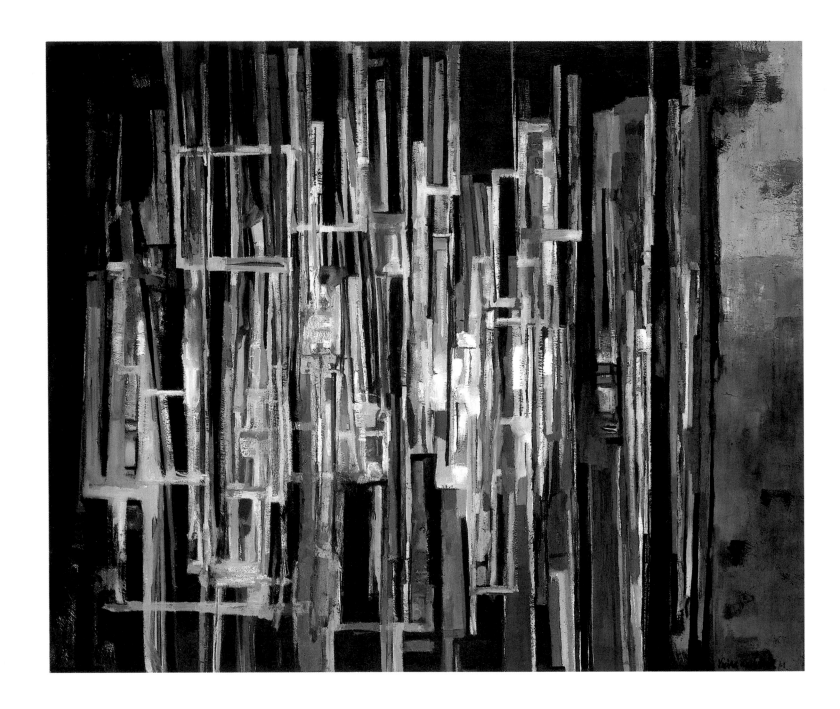

The Easels, 1960
Les chevalets
Oil on canvas, 114 x 137 cm
Washington (D.C.), The Phillips Collection

PAGE 65:
Stele, 1964
Stèle
Tempera on canvas, 195 x 114 cm
Paris, Musée national d'art moderne,
Centre Georges Pompidou

with the large number of entrances. Other scarcely distinguishable figures are moving within the passages. The human figure does not disappear from her work, but adapts in scale to the proportions of the new spaces. Man has not left the buildings, which we see from a distance and an immense height, but has become so tiny that he is invisible within them. "When a face, a human silhouette, a person appears in one of my pictures, "she stated occasionally", it is never a conscious decision of mine. They force their way in. I simply release them, let them appear, allow them access." In the final analysis, her space continues to be a place where human life is led; but man is no longer at the centre of the world, as he was for centuries. Einstein's theory of relativity (1905) and Heisenberg's uncertainty principle (1927)[18] finally and irrevocably drove humankind out of its central position. By overcoming the space established by linear perspective, da Silva also left behind the "dialectic of relationship between space and body and the tradition of anthropocentrism founded by the Renaissance"[19]. But despite everything, she kept to her search for

Chalk, 1958
Craie
Tempera on paper, 71 x 70 cm
Lisbon, Fundação Arpad Szenes – Vieira da Silva

Paris, 1962
Tempera on paper, 68 x 68 cm
France, private collection

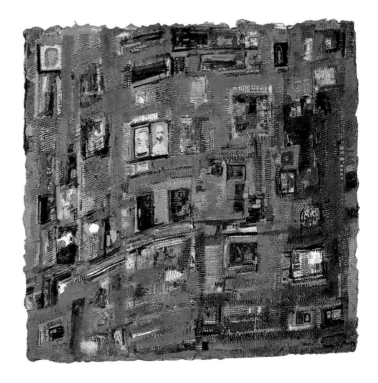

The Collector's Room, 1964
La chambre du collectionneur
Tempera on paper, 68 x 68 cm
Portugal, private collection

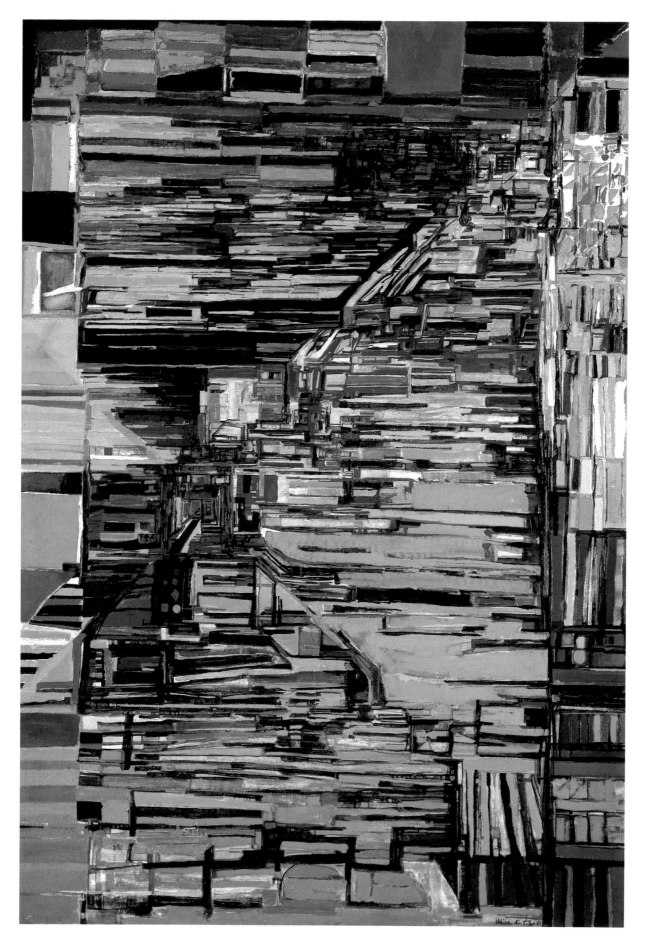

The Steps, 1964
Les degrés
Oil on canvas, 195 x 130 cm
Lisbon, Centro de Arte Moderna, Calouste Gulbenkian Collection

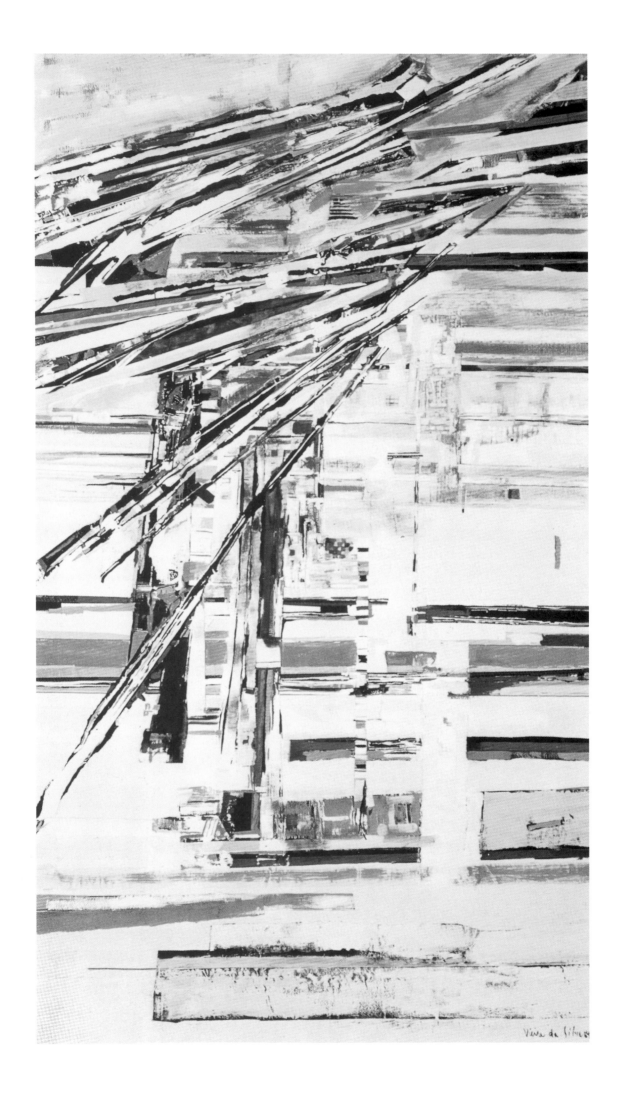

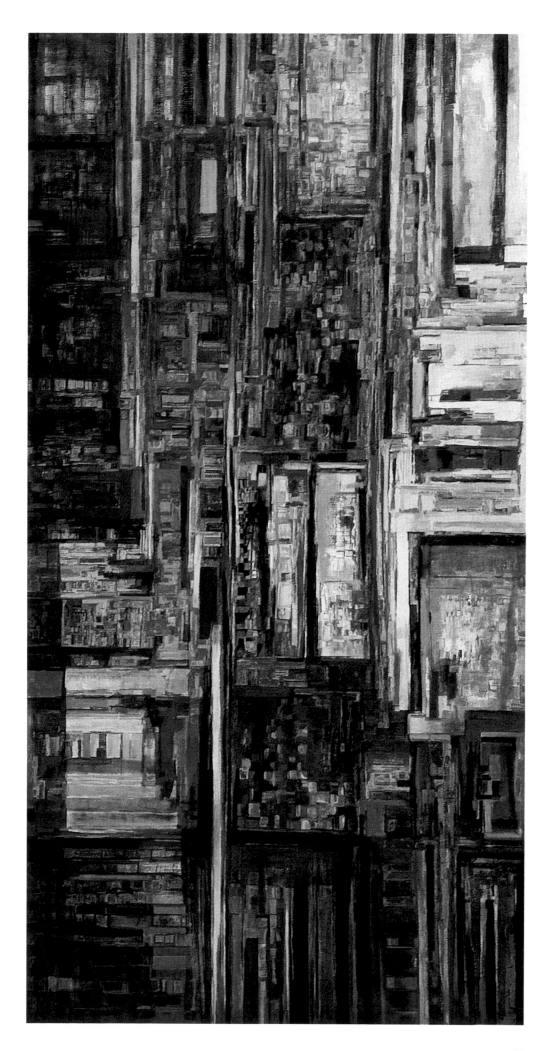

Contradictory Consequences, 1964–67
Conséquences contradictoires
Oil on canvas, 195 x 97 cm
Belgium, private collection

PAGE 68:
The Steps, 1964
Le martinet
Tempera and collage on canvas,
195 x 114 cm
USA, private collection

Equivalence, 1966
L'équité
Oil on canvas, 97 x 195 cm
Belgium, private collection

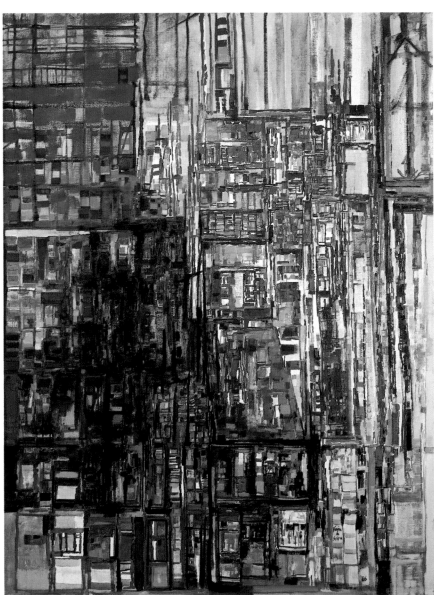

The Library, 1966
La bibliothèque
Oil on canvas, 130 x 97 cm
Paris, Musée national d'art moderne,
Centre Georges Pompidou

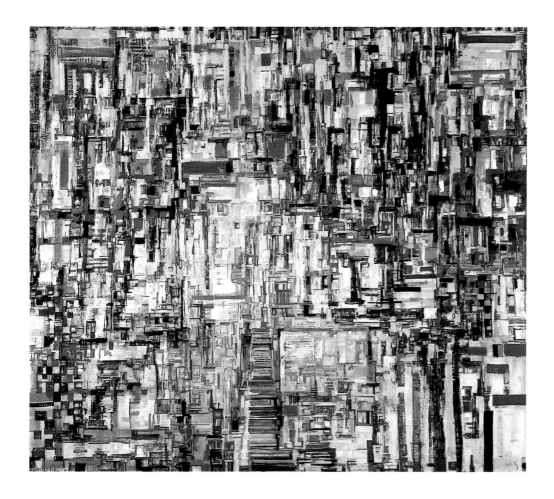

The Unavoidable Route, 1965–67
Itinéraire inéluctable
Oil on canvas, 112.5 x 127.5 cm
France, private collection

"symbolic images for a space-body continuum"[20], an endeavour which her contemporary colleagues had long since given up. In her pictorial spaces, our eyes may happen upon the human figure by chance. It is merely latently absent, and this absence can at times become a visible presence. Thus, despite their abstract idiom, da Silva's paintings never lose sight of empirical reality: "I do not know what non-figurative painting is supposed to be. The starting point for my paintings is always reality. And you must not forget that a painter gets used to looking at things and really knowing what they are like, whereas those who do not paint see nothing but formulas." She saw her pictures as living, organic realms into which she led the viewer's eyes, enticing them to wander and explore: "I do not want people to remain passive, I want them to come and take part in the game, go for a walk, climb up, go down…". Thus pictures such as *The Invisible Walker* (1949/50, p. 50) prove to be direct invitations to enter complex pictorial spaces. A figure, reduced to nothing but dark lines and a nervy bundle of jags, is indicating a visual entry to the painting. It is reminiscent of the figures of girls standing in front of the Lisbon skyline in paintings she did in Brazil. Our gaze as we look at the painting follows a maze as if following Ariadne's thread, constantly coming upon obstacles, being trapped in dead ends and having to start again; and that beholding gaze is essential in order to give the pictorial spaces their temporal dimension, that further *sine qua non* of human life. The depicted space is wide open, in all its ambivalence and contradictions, to our roving eye.

 Gare Saint-Lazare (1949, p. 46) and *The Crowd,* or *The Big Building Site* (1949, p. 45) present the pictorial spaces of public thoroughfares and meeting

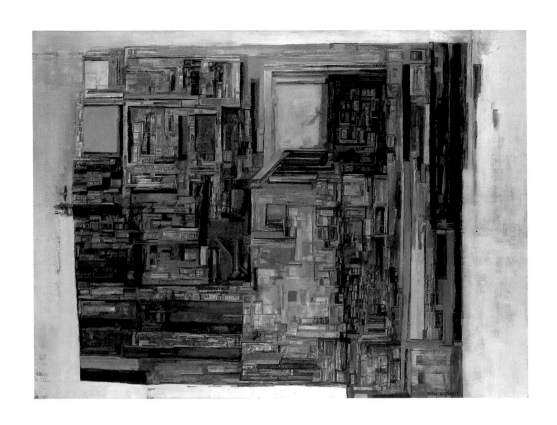

Sleep, 1968/69
Le sommeil
Oil on canvas, 93 x 130 cm
Paris, Musée national d'art moderne,
Centre Georges Pompidou

places, surrounded by a scaffolding of lines and populated with a restless, ant-like mass of dots and dashes or tiny points of colour. The numerous urban scenes which repeatedly inspired her compositions (she once described herself as a "city woman") brought open space back into her paintings. She was fascinated by the modern organization of human conurbations. Cities, stations, airports, subways, bridges and building complexes became symbols of humankind's existence in the modern age. The banal or anecdotal elements of these motifs disappear from a perspective that insists on viewing them from afar. It is a scrutiny that reveals structures, and relativizes that which appeared absolute when seen close up. Whether they are creations floating poetically in the distance, or dark, oppressive spatial structures that fill the entire picture space, they become metaphors. They are visions of a world poised between chaos and order, equal to the images of the empirical reality they refer to, and as autonomous as them; da Silva's formal idiom achieved complete independence in them.

Not until she returned from exile did da Silva finish the painting *The Weavers* (1936–40/48, p. 39), which she had started twelve years previously at the same time as the first studio picture. The study, conceived as a way of going beyond stage-like space, developed into the concept of a new, unlimited spatial construct set against open horizons. The title designates two figures on archaically high-backed thrones, and a third in the centre of the composition which are filling the vast pictorial space with extremely finely-woven lines. In da Silva's hands, art became "an unceasing knotting and untying, weaving and undoing, as if she were keeping a vow of unswerving loyalty"[21]. This distinctly feminine way of appropriating the world, evoking the figure of Penelope, began anew every day in her studio. But what is of interest here is not just the association with the artist's tireless work. From Plato, who gave the older Indian myth of the weaving of the world its classical form[22], she took the image of the three Fates through whose hands the unending threads of human destiny ran.

This was a metaphor that aspired to universal validity, and thus at least met her desire for an all-encompassing account of the world, even if it did not satisfy it. In a catalogue dedication addressed to her friends and written for an exhibition in the Galerie Jeanne-Bucher in 1963, she wrote: "You are all there, vividly present in my imagination. It is yourselves you see here, and a bit of me too, but believe me, I have captured, swallowed and crushed you, and incorporated you into my spider's web." *The Spider's Feast* (1949, p. 47 – the title was inspired by the ballet of the same name by Albert Roussel) implies the platonic analogy of macrocosm and microcosm. The concentric threads of a giant web, upon which a dark spider is sitting, are being drawn around the victim, the world. Though ten years separated this painting from *Man Trapped in a Net*, there is a fundamental affinity in these two artistic outlooks on herself and on the world that bridges the gap implied in the formal differences. Comparison of the different analogies referring to these pictures clearly shows the constant change of paradigm, and this ongoing shift supplies one of the core ambivalences in da Silva's paintings[23]. Her abstract and nonetheless concrete account of the world switches without transition from amazing greatness to infinite smallness.

Memory, 1966/67
Mémoire
Oil on canvas, 114 x 146 cm
Paris, Gallery Jeanne-Bucher Collection

From Mars to the Moon, 1969
De Mars à la Lune
Oil on canvas, 195 x 97 cm
Private collection

ABOVE RIGHT:
New Amsterdam II, 1970
New Amsterdam II
Oil on canvas, 195 x 97 cm
Lisbon, Jorge de Brito Collection

PAGE 75:
The Three Windows, 1972/73
Les trois fenêtres
Oil on canvas, 130 x 97 cm
Lausanne, Alice Pauli Collection

Da Silva subjected "the traditional idiom of painting ... to a meta-morphosis"[24]. However, her painting technique did not become fixed as a system whose abstract signs are merely altered point by point in each new picture and reused in other compositions. Far from it; every painting was a new challenge which she accepted and deliberately met. "My ego, through the experience of self, in an experiment with painting: everything is open, and different every time. That is the starting point. I say something. It could be something different. Or something else again. That is all. Do you understand? I do not firmly believe in what I do and say. Do you understand? That is my deeper nature: I never assert anything. There is also a little of that in my painting. It is all maybe, maybe. It is a path, but this path can branch into three paths or four paths or turn into a dead

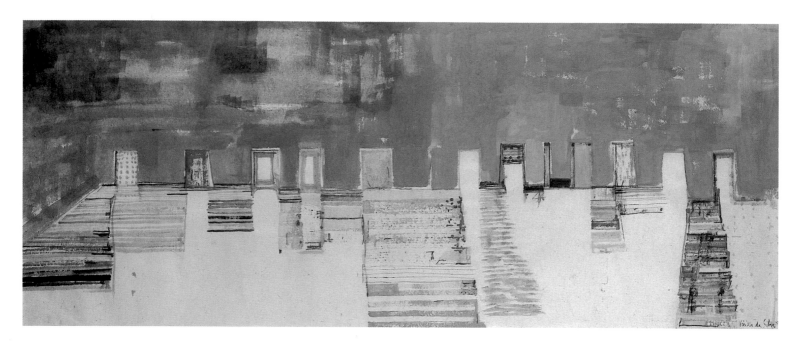

The Thirteen Doors, 1972
Les treize portes
Tempera on Japan paper, 50 x 121 cm
Lisbon, Fundação Arpad Szenes –
Vieira da Silva

Resolute Indecision XXIX, 1969
Les irrésolutions résolues XXIX
Charcoal on primed canvas, 76.5 x 57 cm
Portugal, private collection

end… When I am painting, I do not know that. I do not know it, and yet, I do know it. But… I do not know." Her work grew, developed and changed, all the while remaining true to its origins. Chance discoveries on the way were living impulses to be incorporated and integrated. "I have no system… Without wanting to take this contradiction to extremes, my only system is not to have one." Her paintings were created "by placing one dab of paint next to another, as industrious as a bee." In this intense concentration on daily labour, mental control was of the essence: "Neither Arpad nor I are gestural painters. We try to let our spirits penetrate right into our very fingertips." That disciplined control was evidently compatible with spontaneity: "The idea or the vision is there, but there is a battle between one's hand and head. Sometimes funny things happen because one wants to paint something, but at the same time something different appears that is not bad, but it comes as a surprise." These comments shift the process of painting to a sphere in which rational control is partially eliminated. In some of her statements, da Silva describes a state of transport that possesses her in front of the canvas: "I believe that one does not see what one paints, it is there, it happens here in our bodies and, of course, hands." Once, when John Rewald visited her studio, she told him: "I sometimes paint as if in obedience to a higher inspiration, without really knowing where I am going." And she insisted: "I trust my intuition. I let myself be guided by intuition, and am sceptical of theories." Behind this aesthetic selfassessment lies the conviction of an artist of the modern era, who "through a mystical sense of unity" (Nietzsche) bridges the gap to an alienated world and sees him or herself in the role of creator of all things. With this goes the claim, often hinted at but never spelt out in as many words, to be conveying a message in her pictures: " It is something precious which must blend with my painting in such a way that it becomes visible. If I were to talk about it, some people would think I was absurd, others over-anxious, and yet others too ambitious. So it is better not to talk about it prematurely…"

Wedding, 1971
Noces
Tempera on paper, 53 x 120 cm
Switzerland, private collection

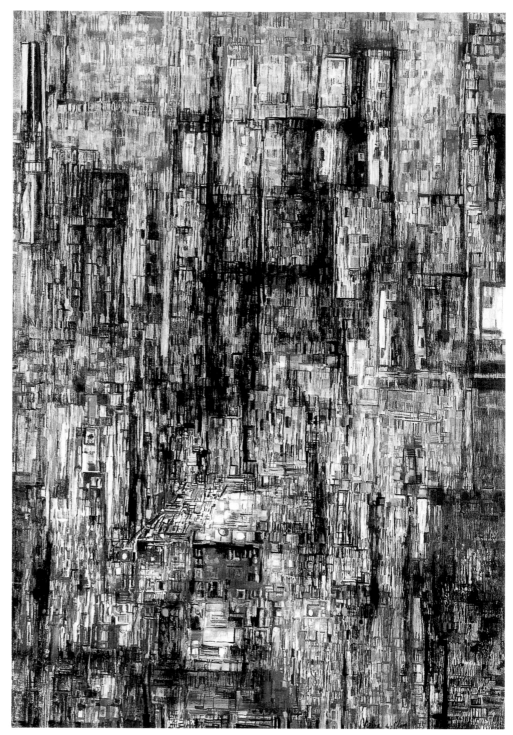

The Celestial Empire, 1977
L'empire céleste
Tempera on wrapping paper, 152 x 52 cm
Paris, Gallery Jeanne-Bucher Collection

Maze, 1975
Dédale
Oil on canvas, 116 x 81 cm
France, private collection

Da Silva's manner of painting reveals clear parallels with the directed chance method of artistic creation practised by contemporary painters of Abstract Expressionism and Lyrical Abstraction. From allowing a minimum of steerage to intervene in chance, it is but a short step to automatism, to which the Surrealists owed their associative work. But the conscious balance which da Silva was at pains to preserve between inspiration and control, spontaneity and governing concept, marked a difference even in her manner of working. Her contribution to post-war painting differs from the "mystical ecstasy"[25] of the Americans Pollock and Rothko, from the abstraction of the Germans Wols and Hartung and the French painters of the École de Paris, and from the "avowal of the irrational"[26] of the Surrealists. "Perhaps," she speculated, "technique and craft are only the

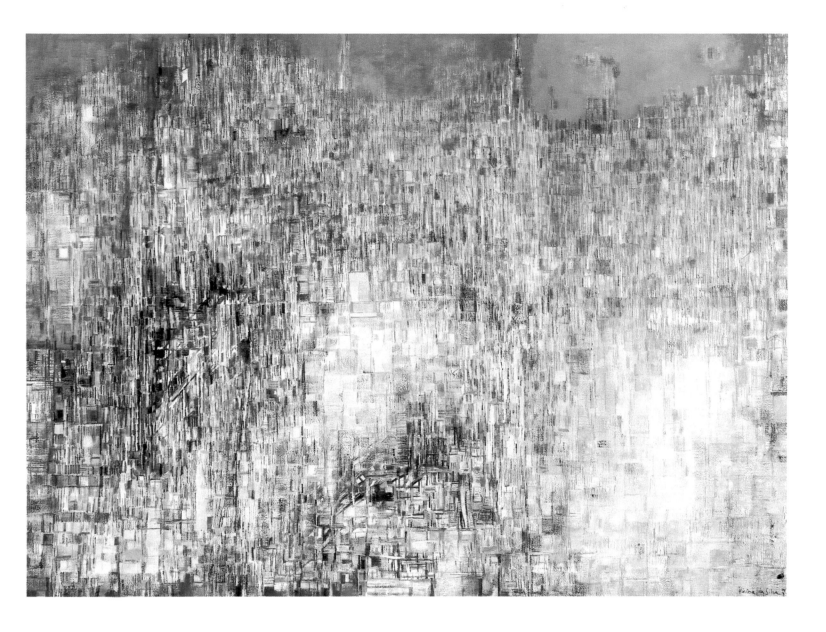

nest which one has to build for this something […] this something, this other thing cannot be forced, I think it is we ourselves."

"Every day I am more amazed about being here and rolling through space on a sphere," she said. "Everything amazes me. I paint my amazement, which at the same time is delight, fear and laughter. I do not want to exclude anything from this amazement. I want to paint pictures with many things, with all the contradictions…" For her, that primal amazement about the world, which grew from an ignorance of final meanings that could not even be dealt with by 20th century science, could be enshrined in the mythical metaphor of the labyrinth. Long before she used that particular spatial figure as the title of a painting, her canvasses were filled with labyrinthine paths around a centre that was difficult to reach or even entirely absent (*Composition*, 1936; p. 18). "I believe I have lived in labyrinths my life long. That is my way of making sense of the world. Even as a child, I knew a small but marvellous 18th century garden which was laid out in the French style with avenues bordered by bushes. It was a real maze, but of course I did not know that. It was extraordinary, and designed like a path of initiation: you went down a few steps, diving into it, went along through it and then the prison opened up mysteriously. There your eyes were met by a marvellous landscape. Just as in those

Light, 1978
Lumière
Oil on canvas, 97 x 130 cm
France, private collection

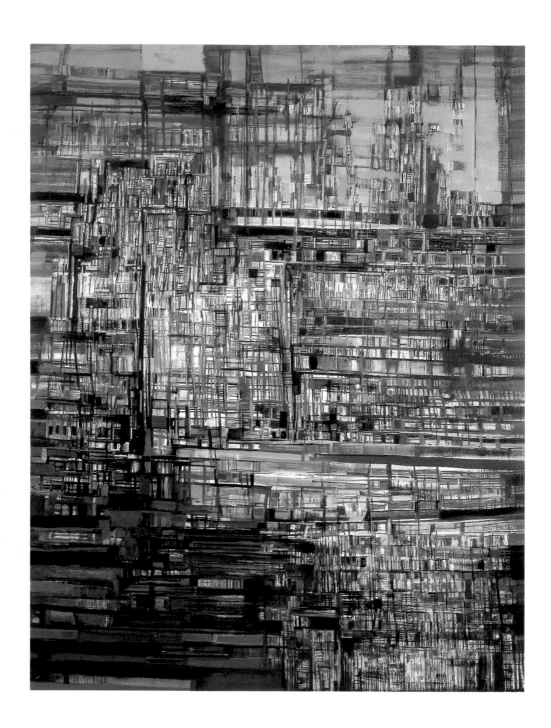

Nocturne, 1978
Oil on canvas, 130 x 97 cm
France, private collection

days I went for a walk in a maze without realising it, so I much later started drawing labyrinths without being conscious of doing so." For da Silva, the labyrinth was both an archetype and a place of actual personal experience. It was a metaphor that could be adopted as an image without fear of being misunderstood, since it was present in the idiom of common speech. The labyrinth could pinpoint something that reason and the word had vainly been attempting to absorb into the sum of human knowledge since the Enlightenment: "There are so many things for which we have no explanation! And how very much I should like to know, not out of fear or the desire for happiness, but in order to satisfy my curiosity. Yes, I should like to understand, and I have the impression that the explanation comes with death; it will give me the key. As long as I live, I shall not know. Nothing that scientists have explained until now accounts for that." Where the question of life and death was concerned, da Silva had no expectation that religions and ideologies would be able to furnish her

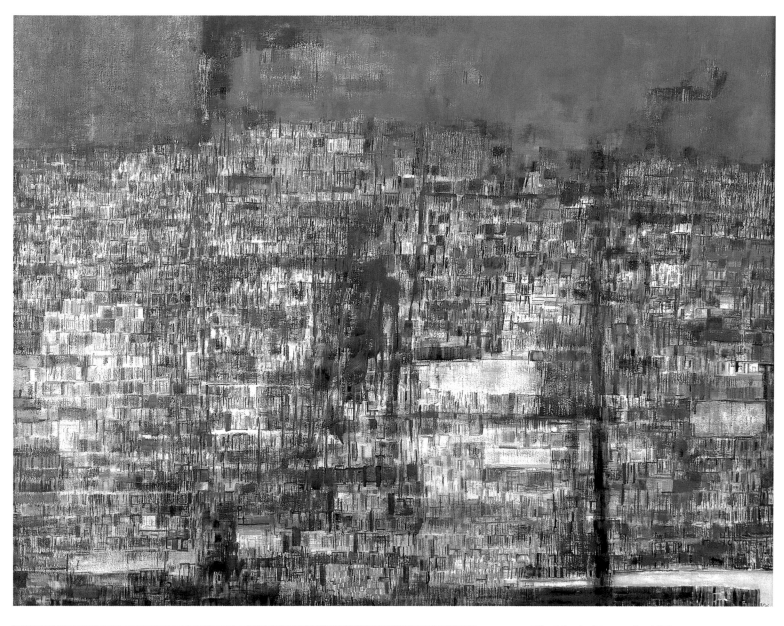

The Magic Mountain, 1978
La montagne magique
Oil on canvas, 89 x 116 cm
Montauban, Museum Ingres

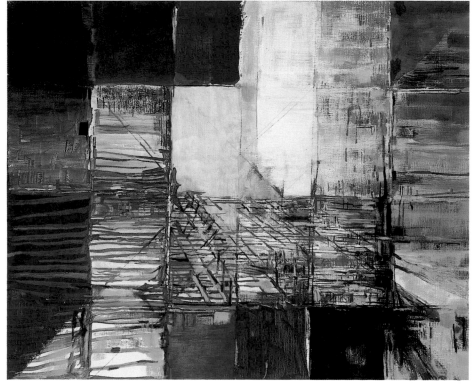

Dislocation of the Labyrinth, 1982
Dislocation du labyrinthe
Oil on canvas, 60 x 73 cm
Switzerland, private collection

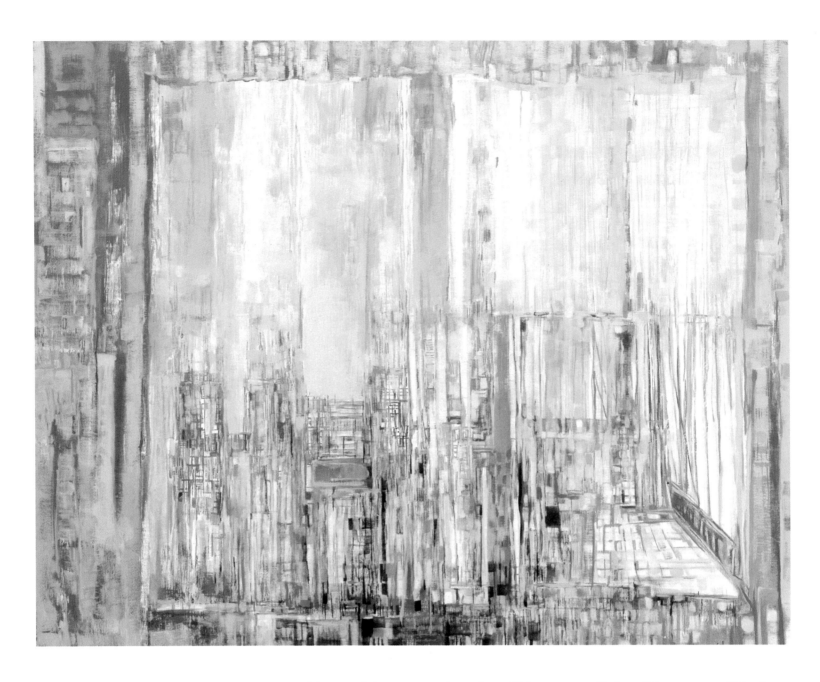

Dialogue on Existence, 1984
Dialogue sur l'existence
Oil on canvas, 81 x 100 cm
Paris, Gallery Jeanne-Bucher Collection

with a satisfactory explanation: "I have no religion. I have no political convictions. I have nothing. I assure you: all I have is uncertainty […] I agree to nothing. That is the truth. For me, everything is relative […]". If the multiple perspectives in her pictures were a first symbol of the co-ordinates of human existence, she made a further venture upon this difficult terrain with the labyrinth, a "mythical archetypal pattern"[27] in which the modern experience of life with its existential fears and hopelessness was relocated and, without abandoning its "essentially enlightened content", was transcended[28]. In contrast to the pictures based on Plato, this was not a retelling of a myth but a concealed truth preserved for the modern age through the metamorphosis of a "mythical structure"[29]. Only in her first painting entitled *Labyrinth* does a spiral structure recall the strict, traditional form of the titular space, the labyrinth, with an entrance and symmetrical, relentless circles converging on the centre. The *Maze* (1975, p. 78), composed of tiny lines and dots of paint which here and there form corridors and passages housing tiny figures, has neither an entrance nor a centre. *Ariadne* (1988, p. 88) takes us into a scaffolding, fragile, multi-storey, bewildering, suspended transparently over an unchanging ground.

The tiny figure gives us a hint of scale: it is a detail of an inconceivably vast whole whose regular form we can only fill in by guesswork. Da Silva's labyrinths remain fragments even where the title expressly refers to them. Evidently, then, the metaphor applies to many of the spatial structures in her works. They are mazes in which our eye becomes hopelessly lost, just as the mazes themselves have lost their centres. Their labyrinthine structures include from the outset the possibility of getting lost, of losing. "The idea of being lost with no hope of help can only be conceived against a background of certainty, order and orientation, it can only be explained as the expression and form of a search for unity and entirety behind the confused nature and fragmentation of the circumstances in which we live..."[30]. Like Kafka in his novels and stories and Beckett in his plays, da Silva succeeded in focusing our attention on this lost unity, by means of her fragmentary construction of a mythic space. But in her case, the process does not end in "self-destruction of the myth, or a shift into the mysterious"[31]; rather, it is an incentive to act on one's own responsibility and initiative. With all its wayward ventures, the path of life can be lost (*The Lost Path*, 1960; p. 62) or take a fateful turn (*The Unavoidable Route*, 1965–67, p. 71), but it can also become a *Path of Wisdom* (1990, p. 89) or *Path of Peace* (1985, p. 84). It is a *Journey to the Limits* (1986) that leads *To the Light* (1991). The path is the positive presence in da Silva's pictures: "In my paintings you see this uncertainty, this terrible labyrinth. That is my heaven, that labyrinth, and perhaps there is just a little certainty to be found in the centre of it." However, this centre in her art is an empty, unoccupied place lit by light from an unknown source. In ancient mythology, this is where the battle between Theseus and the Minotaur took place, a battle for life and death in which Theseus killed the monster. The ancient symbol of the labyrinth has accumulated other meanings over the course of the centuries, and has never lost its relevance. Nietzsche used it as an analogy for the unconscious, in

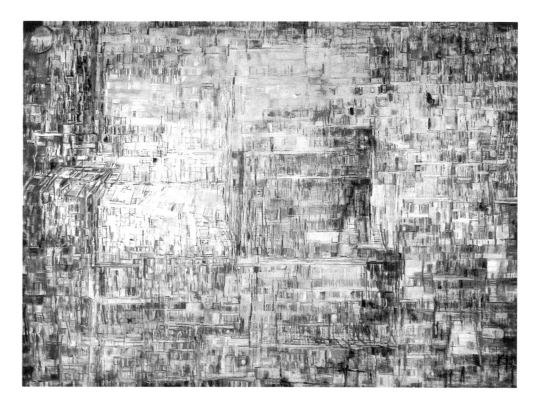

Second Memory, 1985
Mémoire seconde
Oil on canvas, 97 x 130 cm
France, private collection

83

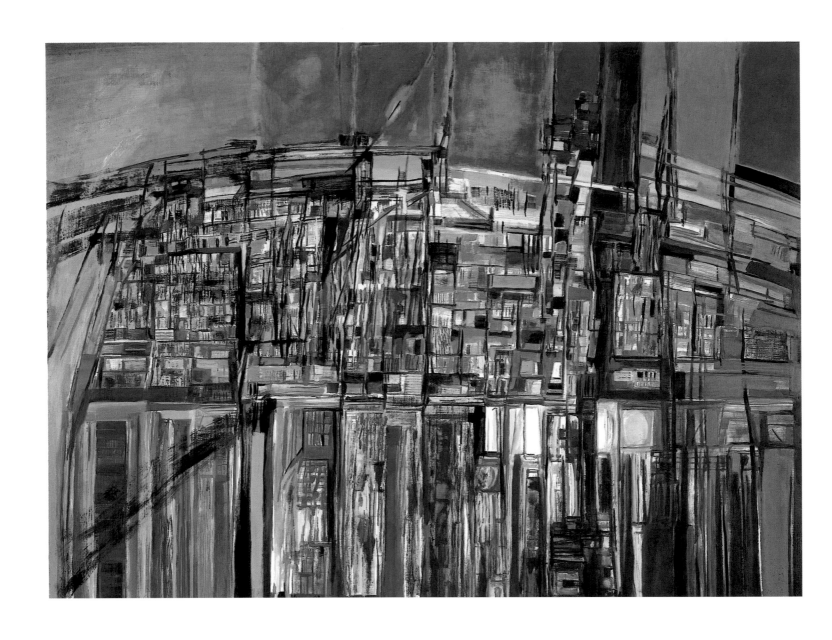

The Ends of the Earth, 1986
Le bout du monde
Oil on canvas, 97 x 130 cm
Paris, Gallery Jeanne-Bucher Collection

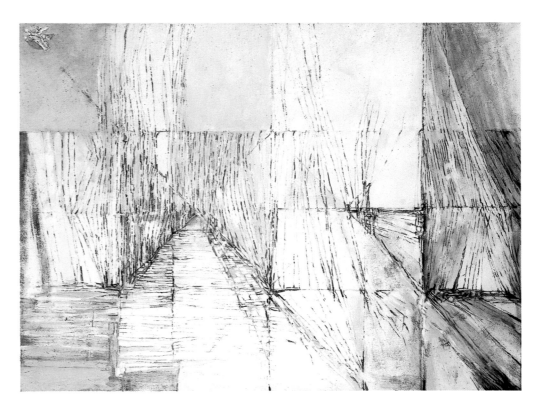

Path of Peace, 1985
Chemins de la paix
Oil on canvas, 73 x 100 cm
Paris, Gallery Jeanne-Bucher Collection

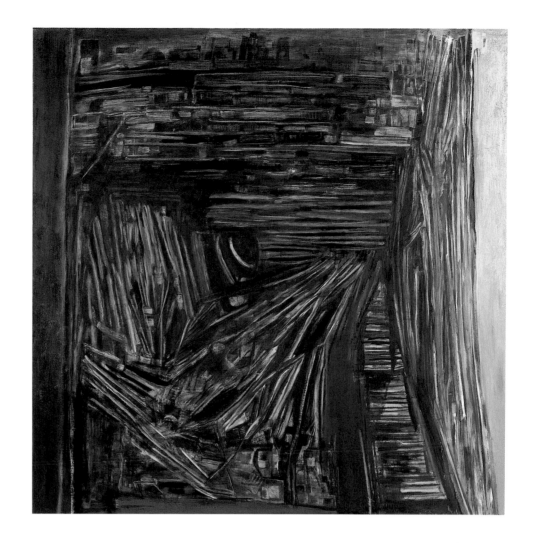

The Return of Orpheus, 1982–86
Le retour d'Orphée
Oil on canvas, 105 x 102 cm
Lisbon, Fundação Arpad Szenes –
Vieira da Silva

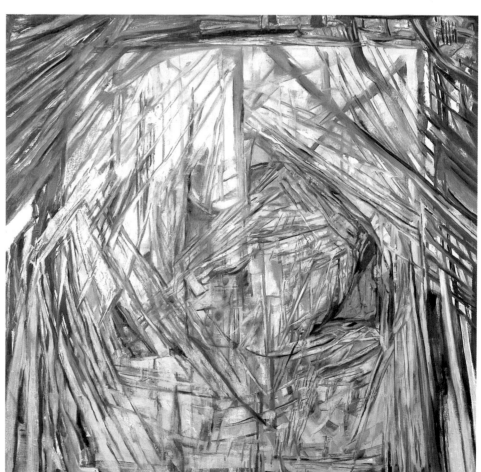

The Fissure, 1984/85
La déchirure
Oil on canvas, 100 x 100 cm
Paris, Gallery Jeanne-Bucher Collection

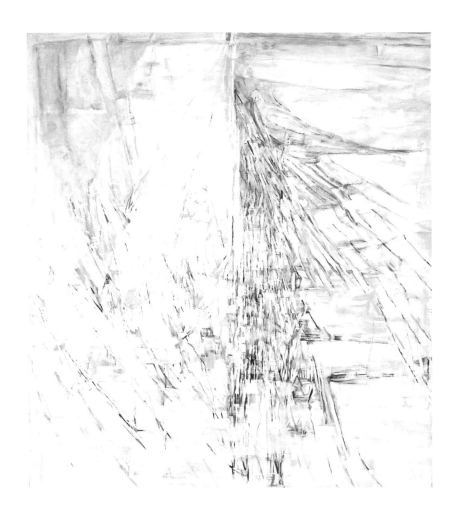

Destiny, 1983–86
Destination
Oil on canvas, 105 x 102 cm
Lausanne, Gallery Alice Pauli

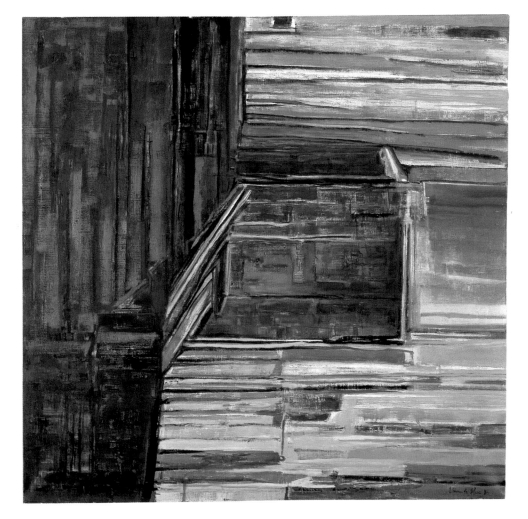

The Secret, 1986
Le secret
Oil on canvas, 80 x 80 cm
Lausanne, Olivier Pauli Collection

PAGE 87:
Suns, 1986
Soleils
Oil on canvas, 130 x 97 cm
France, private collection

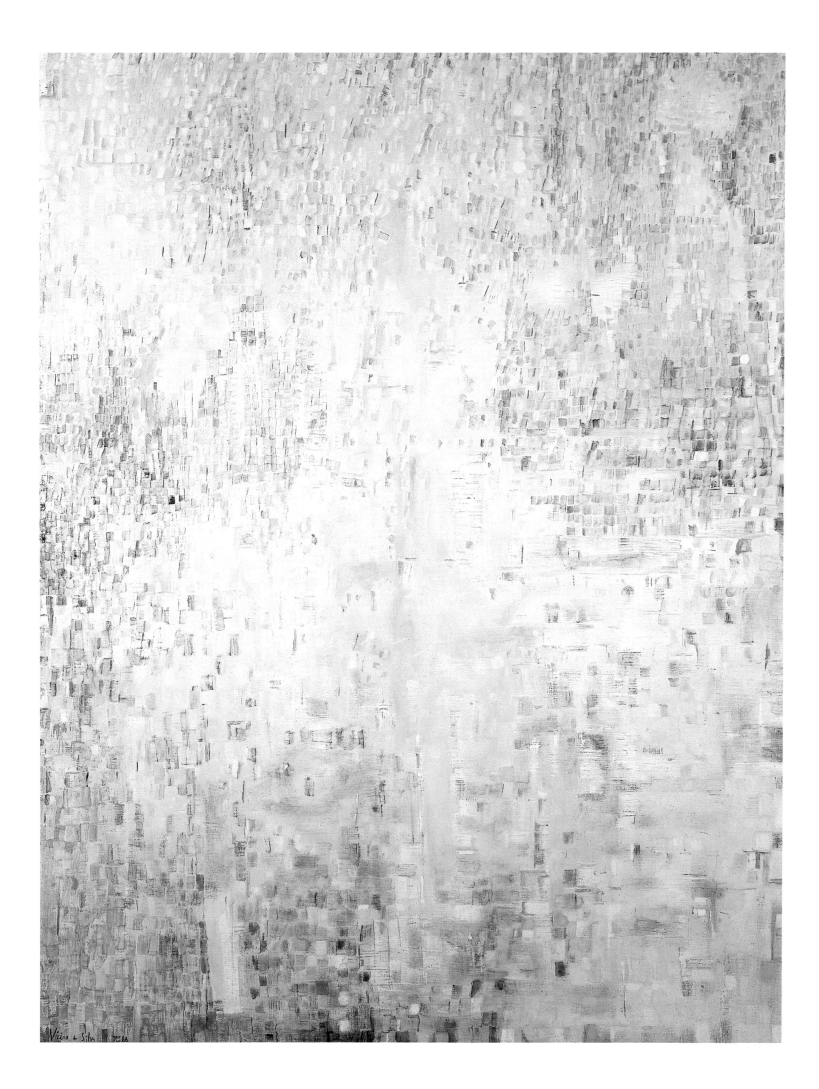

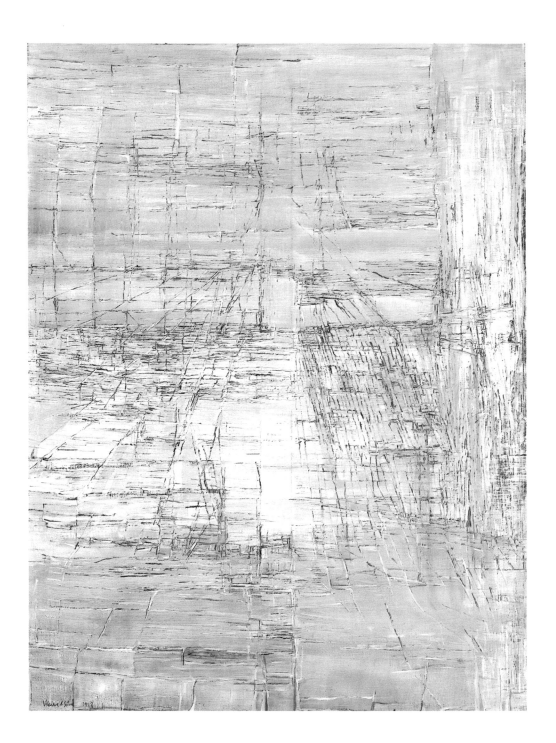

Ariadne, 1988
Ariane
Oil on canvas, 130 x 97 cm
Paris, Gallery Jeanne-Bucher Collection

which Ariadne's thread unwinds in the process of becoming. C. G. Jung saw it as a metaphor of the process by which man attains individual identity: the entire inner space of the ego must be examined if the path of self-knowledge is to lead to one's own centre. "My ego, through the experience of self, in an experiment with painting," was how the artist described her labyrinthine experience in the development of her own work. Whether in the direct or figurative sense, the labyrinth as path of initiation deals invariably with the confrontation and the overcoming of internal and external horrors, leading to a fresh start, like a second birth. But in da Silva's fragments of labyrinths, the centre is also the point beyond which the eye cannot travel: "We (Arpad and Vieira) have no certainty. At times the path of art affords me sudden, fleeting moments of enlightenment, and then I have a temporary feeling of total trust which is well outside the bounds of reason. Profound people who have studied this problem have told me that mysticism explains everything. That would imply that I

am not mystical enough. And I still believe that only death will give me the explanation that I cannot find." The artist's attitude towards life and the essence of her work were internally consistent, defining the condition of man in the modern age as that of an autonomous human being. "With and in space, her painting gains or loses its freedom"[32].

The question of meaning, which had been taken *ad absurdum* in 20th century art as early as 1913 by Marcel Duchamp, could no longer be raised under the conditions of the modern age. Instead, da Silva's theme was the void which it left behind. She presented the ageless, mythical figure of the labyrinth in fragmentary form, thus preserving its complex symbolism: the path has become a maze but still bears with it our questions concerning the final goal, and the centre – now definitively dislodged as the end, as death – still raises the question of where we are from, and where we are going. An integrated totality remains as a luminous possibility. In her art, she succeeded in conveying one of the defining and fundamental feelings of our modern age. Her personal constellation of a being unaccommodated in this world, who started searching while still a child, goes hand in hand with modern consciousness. Her deep knowledge of the dubious nature of all existence and actions led her to foreground the discontinuity and pointlessness of modern life as a permanent condition in her pictures. "Uncertainty, that is what I am; I am uncertainty embodied. Uncertainty is my certainty. I am founded on uncertainty […] That is the truth. Everything is relative for me. What is certainty for me is not so for someone else. What is certainty for someone else is not so for me. The world changes. The eyes change…"

In addition, the abstract-cum-geometrical spatial structure of the labyrinth enabled her to incorporate it completely into her own pictorial idiom. Like Giacometti, she achieved a reconciliation of the seeming irreconcilables of abstraction and figurative art; both artists, in doing so, resolved the conflict between tradition and modern art[33]. Abstraction has a tendency to give up entirely on the world and proffer its own vision instead; but both the sculptor and the painter held on to the world and incorporated it into their works. Giacometti explored the theme of the standing and walking human figure with an almost "obsessive exclusiveness", and took their posture and direction as a means of evoking a lack of certainty "in the boundless vastness of the space around them and the unknown goal they are walking towards"[34]. The theme of being on a journey implied a figurative approach to the human being. But the raw, rough surface of Giacometti's sculptures, and the non-figurative colour values as well as the nervous, tentative approach to faces in his painted portraits, all opened his work to abstract principles of composition. Da Silva, for her part, depicted that unbounded space that Giacometti's figures were passing through. Despite the abstract language, its ambivalence, lack of direction and ambiguity conjure the place where humankind lives, including the human figures. Although no single code has been considered universally valid in the modern age and in its art, da Silva's symbol of a "mystical basic experience"[35] attained the status of a cogent and comprehensive interpretation of life. The mythic figure of the labyrinth became the location for modern experience of the world, and the pictures in which this happened partook of the quality of myth[36]. In this way, her painting went to the limits of what art could possibly accomplish

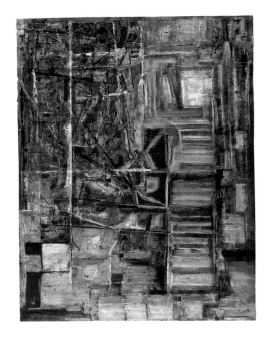

The Path of Wisdom, 1990
La voie de la sagesse
Oil on panel, 105 x 80 cm
Paris, Musée national d'art moderne,
Centre Georges Pompidou

Alberto Giacometti
Three Men Walking, 1948
Bronze, 72 x 40 x 40 cm
France, Maeght Foundation

PAGE 91:
The Struggle with the Angel I, 1992
La lutte avec l'ange I
Tempera on paper, 43.3 x 27.3 cm
France, private collection

The Struggle with the Angel II, 1992
La lutte avec l'ange II
Tempera on paper, 43.3 x 27.3 cm
France, private collection

The Struggle with the Angel III, 1992
La lutte avec l'ange III
Tempera on paper, 43.3 x 27.3 cm
France, private collection

The Struggle with the Angel IV, 1992
La lutte avec l'ange IV
Tempera on paper, 43.3 x 27.3 cm
France, private collection

as the modern era draws to a close: it opened up to "a collective revelation of mythical thought", steeped in the understanding "that man will be removed from life. It is the response to the certainty of death"[37].

The symbol of the labyrinth underwent another metamorphosis in da Silva's art after 1985, following the death of her husband, Arpad. In *The Return of Orpheus* (1982–86, p. 86), the artist confronts us with dark, underground tunnels in which a figure is attempting to free itself; in this way, da Silva articulated her grief at the loss of her long-time companion in life, who had often called her his Eurydice. Her paintings now served as a means of grieving, continuing the dialogue with the deceased. Just as the canvas had been her place to think throughout her life, painting was where she now meditated upon the loss of Arpad and prepared for her own departure. The intense light, which had become increasingly important in her paintings since the beginning of the Sixties, permeated the last paintings as a shining brightness. It is hard to imagine a more compelling way of using light as a medium of personal interpretation. Shortly before Szenes' death, da Silva painted *Dialogue on Existence* (1984, p. 82), in which the two halves of a canvas, each featuring different spatial solutions, merge and become one. In *The Fissure* (1984/85, p. 85), a rift goes right down the middle of a white, unworked canvas, at the heart of a vortex, a destructive whirlwind of lines. In *Destiny* (1983-1986, p. 85), the two halves of a tall canvas define the zones of two opposed spaces. The structure of lines on the right side rises steadily, and a white, scarcely visible bird is sitting on it above the low horizon. Gradually, steadily, the bright centre of the labyrinth in her paintings was starting to come closer. In her last pictures, the dualistic polarity in which her pictorial spaces advanced amid an undefined, timeless and unchanging background of colour to the mythical "ends of the earth"[38] was resolved in the light of an infinite unity. In *Suns* (VII/1986, p. 87) she completed one of Szenes' unfinished canvasses. The smallness of human places, seen from a distance, is as nothing before the radiant light that shines from the centre of the painting. *Paths of Peace* (1985, p. 84) returns to space defined by perspective. On the horizon, a soaring bird is leaving this world behind on its flight into the universe in which other laws apply. And through the *Shining Exit* (1983–86), brightness falls on the world of libraries, where da Silva located *The Path of Wisdom* (1990, p. 89) as opposed to the aimlessness of a life without a goal. In *To the Light* (1991), a path finds its way through the shafts of light shining steeply upwards, into the unspecific infinity of the radiant background. In her last four paintings, she reached the centre of the labyrinth. The angel in the brilliantly radiant *Struggle with the Angel* (I–IV, 1992, p. 91) is the one that stands at death's door. Vieira da Silva died on 6 March 1992, of a wound over the heart which had not healed properly following surgery in 1990. "It really has been too long" were her last words.

Vieira da Silva: Life and Work

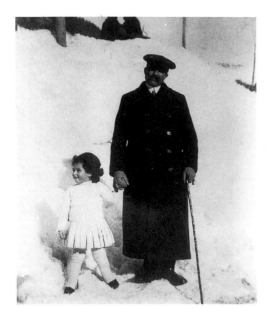

Vieira and her father in Leysin

1908 Maria Helena Vieira da Silva is born on 13 June in Lisbon.

1911 Her father, Marcos Vieira da Silva, economist and diplomat, dies on 14 February. Her father's early death affects her entire life. An only child who accompanied her parents on journeys throughout Europe, she now grows up with her mother in the home of her grandfather, a wealthy newspaper publisher and republican. Vieira is taught by home tutors, without any contact with children of her own age. Due to her

Arpad Szenes and Vieira da Silva

extreme isolation, she becomes interested in reading, music, drawing and painting at a very early age.

1919 Music, drawing and painting are added to her normal subjects.

1924/25 Studies sculpture at the Lisbon Academy of Art. From now on, mother and daughter spend their summers in Sintra.

1926 Takes additional lessons in anatomy. Her mother buys a house in Lisbon, which she and her daughter live in from that time onwards. Da Silva later uses it as a studio whenever she stays in Lisbon with her husband.

1928 At the age of nineteen, she goes to Paris with her mother. She studies sculpture with Bourdelle at the Académie La Grande Chaumière. She discovers early Italian painting on a lengthy trip to Italy. Of the masters of modern art, Cézanne and Matisse make a lasting impression on her.

1929 She takes classes at the Académie Scandinave under the artists Dufresne, Waroquier and Friesz.
In the Atelier 17, she becomes familiar with graphic techniques. She switches from the Académie to the studio of Fernand Léger.

1930 Marries the Hungarian artist Arpad Szenes. The couple move into their own studio flat. Visit to Hungary and Transylvania. First joint exhibition in Portugal.

1931 Visit to Marseilles. First participation in the Salon des Surindépendants and the

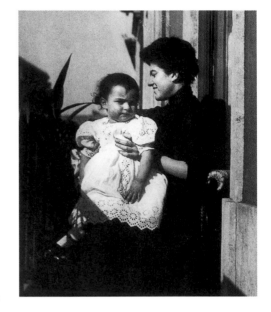

Vieira and her mother in Leysin

Salon d'Automne, Paris, where she regularly exhibits from now on. Travels to Spain and visits the Prado.

1932 Arpad and Vieira take lessons at the Académie Ranson from the artist Bissière. The paintings of Torres García make a lasting impression on Vieira.

1933 First solo exhibition in the Galerie Jeanne-Bucher. Da Silva remains loyal to this gallery, even after the death of Jeanne Bucher in 1948.

1934 Seriously ill with jaundice.

1935 Vieira and Arpad take part in the meetings of the 'Amis de Monde' group (until the end of the Thirties). Solo exhibition in Lisbon in the UP Gallery. Lengthy stay in Lisbon.

1936 Vieira and Arpad exhibit recent works in their Lisbon studio.

1937 The couple meet Matisse and Braque, and copy two pictures for them as patterns for tapestries.

1938 Vieira and Arpad move into a larger studio flat on the Boulevard St. Jacques.

1939 Jeanne Bucher and da Silva organize the sale of paintings in aid of the children of Spanish exiles. Exhibition at the Galerie Jeanne-Bucher, together with Szenes and the Hungarian sculptor Etienne Hajdu. The couple move to Lisbon in September, in order to evade the threat of German invasion. A large picture of Lisbon, which the Portuguese government commissioned

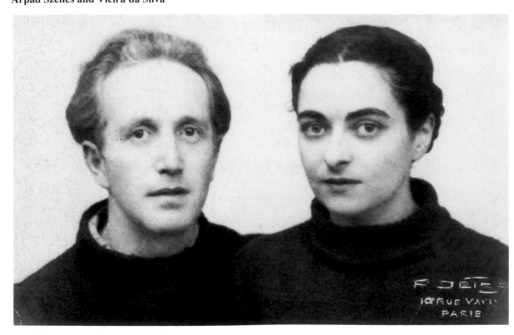

Vieira da Silva and Arpad Szenes in the garden of the International Pension

Vieira da Silva and Arpad Szenes in the studio, Boulevard Saint-Jacques, Paris, 1938

from da Silva for the Colonial Exhibition in 1940, is criticised and destroyed shortly before the show opens.

1940 Da Silva fails to regain the Portuguese nationality which she forfeited when she married. In June, she and Szenes go into exile in Brazil. They settle in Rio de Janeiro.

1942 Solo exhibition at the National Museum of Fine Arts in Rio de Janeiro. In Uruguay, the artist Joaquim Torres García publishes an enthusiastic article on her painting.

1943 Da Silva receives an official commission to produce a large panel of tiles to decorate the agricultural college of the federal district of Rio de Janeiro. The artist Carlos Scliar makes a short film about the two artists.

1944 Solo exhibition at the Ashkanazy Gallery in Rio de Janeiro. Szenes starts a very popular art course in his studio.

1945 Exhibits at the Salon des Réalités Nouvelles, Paris, for the first time.

1946 Exhibition at the City Palace in Belo Horizonte (with Szenes). Jeanne-Bucher organises da Silva's first New York exhibition, using the works produced in Brazil. The artist Marc Tobey, later to become a friend of the couple, buys one of her works.

1947 Vieira returns to Paris in March. Arpad follows in May, after completing his art course. They move into their old studio, and stay there until 1953. Exhibition at the Galerie Jeanne-Bucher.

1948 The first work of da Silva's that the French government buys is *The Game of Chess*. Solo exhibition at the Galerie Jeanne-Bucher.

1949 Solo exhibitions at Galerie Pierre Loeb, Paris and Galerie Trouvaille, Lille. Pierre Descargues writes the first monograph on da Silva.

1950 Solo exhibition at the Blanche Gallery, Stockholm.

1951 The Galerie Jeanne-Bucher, which has been managed by Jean-François Jaeger since Bucher's death, publishes the children's stories *Et puis voilá* with five gouache paintings by da Silva. Solo exhibition at the Galerie Pierre Loeb, Paris.

1952 Solo exhibition at the Galerie Dupont, Lille. Exhibits for the first time in the

Pittsburgh International Exhibition of Contemporary Painting, Carnegie Institute of Pittsburgh, and in the Salon de Mai, Paris.

1953 Prize at the II Biennale of the Museum of Modern Art, São Paulo.

1954 Exhibition at the Kunsthalle, Basle, with the artists Bissière, Schiess, Ubac and Germaine Richier. First prize in the tapestry competition of the University of Basle. Guy Weelen takes on the task of organizing the work and exhibitions of both artists. First works using tempera. Solo exhibition at the Cadby Birch Gallery, New York. Exhibits in the XXVII Biennale in Venice.

In the studio

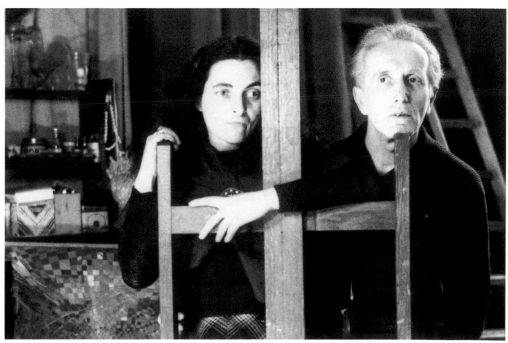

Vieira da Silva in Brazil

1955 Joint exhibition in Amsterdam with the sculptress Germaine Richier. One of the exhibited works is a collaboration between the two artists. Solo exhibition at the Galerie Pierre Loeb, Paris.

1956 Da Silva and Szenes are granted French nationality. They move to the Rue de l'Abbé Carton. Solo exhibitions at the Galerie du Perron, Geneva; Saidenberg Gallery, New York; Pórtico Gallery, Lisbon; and Galerie Marie-Suzanne Feigel, Basle. René Solier publishes the second monograph on da Silva.

1957 Solo exhibition at the Hanover Gallery, London.

1958 First retrospective at the Kestner Gesellschaft, Hanover; Kunst und Museums-verein, Wuppertal; and Kunstverein, Bremen. José-Augusto França writes the first Portuguese study of her art.

1959 A collection of poems by René Char, *L'inclémence Lointaine*, is published with 25 etchings by da Silva. Exhibits at the second Kassel documenta show.

1960 The French state confers the honour of Chevalier de l'Ordre des Arts et des Lettres on her. She and Szenes buy 'La

Maréchalerie', an old country house in Yèvre-le-Châtel, where they spend their summers from now on. Solo exhibition at the Galerie Jeanne-Bucher. Guy Weelen publishes the fourth monograph.

1961 Solo exhibitions at Knoedler Gallery, New York, and the Duncan Phillips Collection, Washington. International Art Prize at the Biennale of São Paulo.

1962 The French state makes her a Commandeur des Arts et des Lettres. Retrospective at the Städtische Kunsthalle, Mannheim.

1963 Exhibition of graphic works at the Bezalel National Museum, Jerusalem. Exhibition of works on paper at the Galerie Jeanne-Bucher; Knoedler Gallery, New York; and the Phillips Collection, Washington.

1964 Commissioned by Jacques Lassaigne to produce her first stained-glass window. Exhibits in the Salon des Galeries Pilotes, Lausanne, and the third Kassel documenta. Retrospective in Turin.

1965 First tapestry on a pattern produced by the artist, manufactured by Beauvais.

1966 Solo exhibition at the Knoedler Gallery in New York. Commissioned to produce eight stained-glass windows for the Church of Saint-Jacques in Rheims. National Prize of the Arts, Paris.

1967 Solo exhibition at the Galerie Jeanne-Bucher. Exhibits in the third International Tapestry Biennale, Lausanne, and the second International Exhibition of Drawing, Darmstadt.

1968 Working on stained-glass windows for Rheims.

1969 Solo exhibition at the Comédie de la Loire, Tours. Retrospective in the Musée Nationale d'Art Moderne de Paris and the

The house and studio at 34 Rue de l'Abbè-Carton, Paris
Photo: Pierre Joly, Vera Cardot

Museum Boijmans Van Beuningen, Rotterdam. Solo exhibitions at the Galerie Jeanne-Bucher, Paris and the Galerie Jacob, Paris (works on paper).

1970 Retrospective at the Kunstnernes Hus, Oslo; Kunsthalle, Basle; and the Gulbenkian Foundation in Lisbon. Solo exhibitions at Gallery 111, Lisbon and the S. Mamede Gallery, Lisbon.

1971 Solo exhibitions at the Knoedler Gallery, New York and the Zen Gallery in Porto. Retrospective at the Musée Fabre, Montpellier and the Galerie Jeanne-Bucher. Publication of *La Peinture de Vieira da Silva. Chemins d'Approche* by Dora Vallier. Working on three further stained-glass windows for Rheims.

1972 Graphics exhibition at the Musée des Beaux-Arts, Rouen, and the Musée Thomas-Henry de Cherbourg. Exhibits lithographs at the Galerie Véga, Liège. Retrospective at the Museum Unterlinden, Colmar. Exhibits with Szenes at the Judith Dacruz Gallery in

Vieira da Silva working on *Star*, 1949

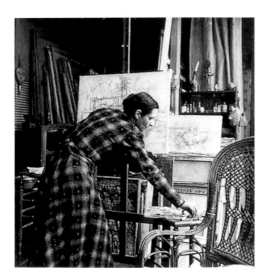

Maywald, Vieira da Silva, Arpad Szenes, Charlotte Hockenheimer and Etienne Hajdu

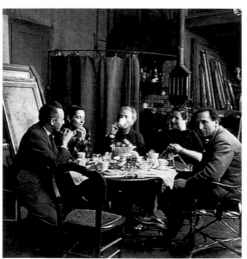

La Maréchalerie, in their first summer there

Lisbon. Plato's *Symposium* appears in M.P. Boutang's French translation with 39 drawings by da Silva.

1973 Retrospective at the Musée d'Orléans. Graphics exhibition at the Maison de la Culture d'Orléans. Publication of a new study of her art by Guy Weelen. Working on the stained-glass windows for Rheims.

1974 Graphic portrait of André Malraux for the publication of *Malraux, celui qui vient* by Guy Suarès. Solo exhibition at the Galerie Artel, Geneva.

1975 Da Silva designs two posters dealing with the Portuguese revolution of 1974, which are published by the Gulbenkian Foundation.

1976 Publication of seven portraits of René Char with a text by the poet. Mini-retrospective at the Galerie Jeanne-Bucher. Solo exhibition at the Maison des Arts et Loisirs, Sochaux. Exhibition at (and gift to) the Musée national d'art moderne du Centre Pompidou, Paris. Retrospective at the Musée d'Etat de Luxembourg and Musée de Metz. Working on the stained-glass windows for Rheims.

1977 Solo exhibition at the Galerie Kutter, Luxembourg. Retrospective (works on paper) at the Musée d'Art Moderne de la Ville de Paris and the Gulbenkian Foundation, Lisbon. Publication of the catalogue of graphic works by Guy Weelen, and exhibition at the Galerie La Hune, Paris. First critical study of the works on paper by Antoine Terrasse.

1978 Retrospective at the Nordjyillands Art Museum, Aalborg, Denmark. José Alvaro Morais makes the documentary film 'Ma femme chamada Biche' about da Silva, with a commentary by Szenes. Publication of a new biography by Jacques Lassaigne and Guy Weelen. Joint exhibition at the Galerie Jeanne-Bucher with Louise Nevelson and Magdalena Abakanowicz.

1979 The President of the French Republic appoints her a Chevalier de l'Ordre National de la Légion d'Honneur.

1980 Exhibition (works on paper) at the Joan Prats Gallery in Barcelona and the Nova Spectra Gallery, The Hague. Publication of *Méditerranée*, poems by Sophia de Mello Breyner Andresen, with two serigraphs by da Silva.

1981 Commissioned by the French state to produce five panels for the French embassy in Lisbon. Retrospective of her graphic works at the Bibliothèque Nationale de Paris.

1982 Solo exhibitions at the Galerie Jeanne-Bucher and the Galerie de l'Information, Tunis.

1983 Exhibition in the Rencontres d'Art de Quercy, Musée Ingres de Montauban. Accepts an invitation at decorate the new subway station at the University of Lisbon. Her starting point is her gouache painting, *Métro*, dating from 1940. Manuel Cargalero transfers the designs on site.

1984 The first internationale Biennale of drawing at Clermond-Ferrand focuses on Vieira's work. Exhibitions at the French Cultural Centre, Rome and the Emi Valentim Gallery in Lisbon (with Arpad). Vieira's exile in Brazil is the subject of a dissertation by Nelson Alfredo Aguilar.

1985 Arpad Szenes dies on 16 January. Exhibitions at the Galerie 111, Lisbon and the Galerie la Belle Époque, Lyons.

1986 Poster design for UNESCO's Year of Peace. Awarded the Florence Gould Prize, Paris, and the Grand Prize of Antena I, Lisbon. Exhibitions at the Galerie Jeanne-Bucher and the Artcurial in Paris and the Nasoni Gallery in Porto.

1987 Exhibitions at the Museu de Arte, São Paulo; the Bertrand Gallery, Lisbon (with Arpad); Musée Granat, Aix-en-Provence; and Musée Petrarque, Fontaine-de-Vaucluse. Da Silva's graphics are exhibited in Bellac, Caen, Toulouse and Blagnac.

1988 Exhibition at the Gulbenkian Foundation in Lisbon and the Centre National des Arts Plastiques de Paris, Grand Palais, Paris. Opening of the subway station Cidade Universitária in Lisbon, with tiles designed by the artist. A study of Da Silva's art by Claude Roy is published.

1989 Exhibitions at the Casa de Serralves, Porto (with Arpad); Galeria Funchália, Funchal, Madeira; and the Maison des Princes, Pérouges. Guest of honour at the 20th Biennale in São Paulo.

1990 Work begins on a catalogue of her works. Foundation of the Fundação Arpad Szenes – Vieira da Silva in Lisbon. Exhibitions at Tre Art, Toulouse; Galerie Georges Pompidou; the Bibliothèque Municipal de Abglet; and the Maison Noubel, Carcassonne. Da Silva has been ill for over a year and undergoes surgery.

1991 Da Silva is created an Officier de Légion d'honneur. Exhibitions at the Cultural Institute, Macao; the Joan March Foundation, Madrid; and the Galerie Patrick Derom, Bruxelles. Retrospective at the Européalia, Bruxelles.

1992 Vieira da Silva dies on 6 March.

Vieira da Silva

In her studio

The artist's hand

Notes

1 Quotations from the artist in this text were drawn from the following sources:
Aguiar, N. A.: 'Vieira da Silva no Brasil', in: *Colóquio de Artes*, Lisbon, 1976
Charbonier, G.: *Le monologue du peintre – entretiens*, Paris, 1978
França, J. A.: 'Portrait de Vieira da Silva', in: *Aujourd'hui Art et Architecture* no. 45, Boulogne-sur-Seine, April 1964
Huser, F.: 'Vieira da Silva dans le Labyrinthe', *Le Nouvel Observateur*, Paris, 20 March 1982
Exhibition Catalogue: *Vieira da Silva*, Galerie Jeanne-Bucher, 1963
Lafaye, J. J.: 'Vieira da Silva, la contemporaine capitale', in: *Connaissance des Arts*, Paris, September 1988
Lourenço, E.: 'Itinerário de Vieira da Silva ou da poésia como espaço', in: Lourenço, E.: *O Espelho Imaginário*, Lisbon, 1981
Layaz, A.: 'M. H. Vieira da Silva', in: *Le Magazin des Arts* no. 59, Lausanne, May 1989
Noel, B.: *Vieira da Silva – Rencontre*, Paris, 1994
Philipe, A.: *L'Éclat de la Lumière. Entretiens avec M. H. Vieira da Silva et Arpad Szenes*, Paris, 1978
Pingaud, B.: 'Parler avec les peintres. Vieira da Silva', in: *L'Arc*, Aix-en-Provence, 1960
Rewald, J.: *Une visite à Vieira da Silva*, 1974
Roy, C.: *Vieira da Silva*, Barcelona, 1988
Schneider, P.: *Les Dialogues du Louvre*, Paris, 1994
Vallier, D.: *Chemins d'Approche – Vieira da Silva*, Paris, 1982
Vezin, L.: 'Entretien. Vieira da Silva, les naissances successives', in: *Beaux-Arts Magazine* no. 61, Levallois-Perret, October 1988
Weelen, G.: *Vieira da Silva*, Paris, 1973
Weelen, G. et al.: *Vieira da Silva – Catalogue Raisonné et Monographie*, 2 vols., Geneva, 1993
2 Daval, J. L.: 'Renouveler l'experience du voir', in: *Vieira da Silva – Monographie*, 1993, p. 93
3 Belting, H.: *Max Beckmann – Die Tradition als Problem in der Kunst der Moderne*, Berlin, 1984, p. 27
4 Luís de Camões: *The Lusiads* (1st Canto), translated by William C. Atkinson, London, 1952 etc., p. 56
5 Cézanne's *Card Players* (1890/95) and Matisse's *The Dance* (1st version, 1909) provided the thematic inspiration. The motif of the chess board, which Vieira returned to later on several occasions, appears in several of Matisse's paintings.
6 Aguiar, N. A.: 'Vieira da Silva no Brasil', loc.cit., p. 12
7 Lourenço, E.: 'Itinerário de Vieira da Silva ou a poésia do espaço', in: Lourenço, E., 1981, p. 74
8 On the symbolism of the four points of the compass and the crucifix as the basic configurations of spatial representation, see Guénon, R.: *Le Symbolisme de la Croix*, Paris, 1996 (1st ed. c. 1930)
9 Rudolf Bultmann, quoted from Jamme, C.: *Gott hat ein Gewand an. Grenzen und Perspektiven des philosophischen Mythos – Theorien der Gegenwart*, Frankfurt, 1991, p. 199
10 Merleau-Ponty, quoted from Jamme, C., 1991, p. 257
11 Plato: *The Republic* X
12 Lourenço, E., 1981, p. 78
13 Blumenberg, H.: *Arbeit am Mythos*, Frankfurt, 1996, p. 194
14 A systematic appraisal of da Silva's literary knowledge and tastes has not yet been made. At present, her large library is being stored in crates. An examination of them will surely provide valuable new insights.
15 Lourenço, E., 1981, passim
16 Arpad Szenes, quoted from Cézariny, M.: *Vieira da Silva – Arpad Szenes ou o Castelo Surrealista*, Lisbon, 1984, p. 99
17 On the formal development of her painting after 1947, see in particular Dora Vallier, 1982, and *Vieira da Silva – Monographie*, 1993
18 Dora Vallier: *A Arte Abstracta*, Lisbon, 1986, pp. 242 ff.
19 Hofmann, W.: *Die Grundlagen der modernen Kunst. Eine Einführung in ihre symbolischen Formen*, Stuttgart, 1987, p. 425
20 Hofmann, W., 1987, passim
21 Lourenço, E., 1981, p. 74
22 Plato, passim; Guénon, R., 1996, p. 124
23 Vieira uses an approximation of the microcosm in paintings such as *The Cycle of the Seasons* (1960), *Winter* (1960), or *The Waterfall* (1960)
24 Vallier, D., 1982, p. 15
25 Blumenberg, H., 1996, p. 167
26 Bocola, S.: *Die Erfahrung des Ungewissen in der Kunst der Gegenwart*, Zurich, 1987, p. 62
27 ibid, p. 53
28 Jamme, C., 1991, p. 285; also Belting, H., 1984, p. 51; D. Vallier, 1982, pp. 111 ff.
29 Jamme, C., 1991, p. 287
30 Kern, H.: *Labyrinthe. Erscheinungsformen und Deutungen. 5000 Jahre Gegenwart eines Urbilds*, Munich, 1983, p. 448
31 Jamme, C., 1991, passim
32 Lourenço, E.: 'Vieira da Silva – Uma poética do Espaço', in: Lourenço, 1981, p. 114
33 On the conflict of tradition and modernism, see Belting, H., 1984, p. 17
34 Bocola, S., 1987, p. 89
35 Jamme, C., 1991, passim
36 Belting, H., 1984, p. 57; on the concept of the mythical see Jamme, C., 1991, pp. 175 ff.
37 Jamme, C., 1991, p. 269
38 Blumenberg, H., 1996, p. 14

Photo credits